The Best of
"I Remember Dahlonega"

The Best of
"I Remember Dahlonega"

Anne Dismukes Amerson

Published by The History Press
Charleston, SC 29403
www.historypress.net

Copyright © 2006 by Anne Dismukes Amerson
All rights reserved

Front Cover: Courtesy Dahlonega Gold Museum
Back Cover: Charlie Turner's pet bear, "Smoky," was so tame that children rode on his back; the boy pictured is not identified. *Courtesy of Elizabeth Sparks.*

First published 2006; Second printing 2015

Manufactured in the United States

ISBN 978.1.54020.409.7

Library of Congress Cataloging-in-Publication Data

Amerson, Anne.
The best of "I remember Dahlonega" : memories of Lumpkin County, Georgia /
Anne Amerson.
p. cm.
Includes index.
Reprint of newspaper articles that originally appeared in the Dahlonega Nugget.
ISBN 1-59629-125-7 (alk. paper)
1. Dahlonega (Ga.)--History--Anecdotes. 2. Lumpkin County (Ga.)--History, Local--Anecdotes. I. Title.
F294.D13A44 2006
975.8'273--dc22
2006009235

Notice: The information in this book is true and complete to the best of our knowledge. It is offered without guarantee on the part of the author or The History Press. The author and The History Press disclaim all liability in connection with the use of this book.

All rights reserved. No part of this book may be reproduced or transmitted in any form whatsoever without prior written permission from the publisher except in the case of brief quotations embodied in critical articles and reviews.

Contents

Preface 9
Acknowledgements 13
Introduction—Before There was a Dahlonega 15

1. Gold Fever! 17
 John Crisson Remembers His Gold Mining Ancestors
 Marion Boatfield Remembers Gold Mining Being Like Gambling
 Robert Jenkins Remembers Finding Gold Nuggets on the Public Square
 C.C. Davis Remembers a Mining Tunnel
 Ross Adams Remembers Feeding the Stamp Mills

2. The Cherokees Called North Georgia "The Enchanted Land" 26
 Walker Dan Davis Remembers His Cherokee Ancestors
 J.B. Jones Remembers Growing Up in Frogtown

3. Auraria: From Boomtown to Ghost Town 32
 Agnes Paschal Was Auraria's "Angel of Mercy"
 Amy Trammell Was Auraria's Lady Gold Miner

4. They Wore Both Blue and Gray 38
 Civil War Stories

5. Living on the Land 43
 Memories of Life on the Farm

6. Always Plenty to Do 48
 Maggie Waters Wehunt Remembers Making "Leather Britches"
 Sam and Lois Saine Remember When Nobody Locked Their Doors

Contents

 Nettie Collins Remembers Getting Married at Fifteen
 Curly Pruitt Remembers Drawing Water from the Well
 Viola Berry Fields Remembers Clearing New Ground to Farm
 Fannie Lou Bryan Remembers Boiling Eggs and Baking Corn Bread
 Vernon Glaze Remembers Meeting His Wife at a Cotton Pickin'
 Duffie Grizzle Remembers When Shoes Were the Same for Both Feet

7. Getting from Here to There, Back Then 63
 Memories of Early Roads and Vehicles
 Helen Head Green Remembers Learning to Drive a T-Model
 Clarence Cochran Remembers When His Dad's Mail Car Floated Down Bull Creek
 Elizabeth Moore Remembers When Woody Gap Road was Built with Picks and Shovels

8. Making Moonshine 74
 Larry Odum Remembers Sara Christian, the First Woman Driver in a NASCAR Stock Race
 Homer Rider Remembers Running from Revenuers
 Herman Caldwell Remembers Telltale Smoke

9. Doing Business in Dahlonega 79
 Memories of Early Stores and Shops
 Eli Abee Remembers "Diving for Pearls" at the Smith House
 Fred Butler Remembers Tempering Steel in his Dad's Blacksmith Shop

10. The Three Rs: Reading, 'Riting and 'Rithmetic 88
 Memories of Getting Educated in One-Room Schoolhouses
 Lillie Chester Christian Remembers Early "School Buses"

11. Having Fun Doing Work 94
 Memories of Corn Shuckin's, Cotton Pickin's and Fiddling Contests

12. Animal Tales 98
 Florethel Satterfield Remembers a Smelly Encounter
 Oscar Cannon Remembers Charlie Turner's Pet Bear
 Clarence Cochran Remembers the Half-Chicken/Half-Rooster
 Arch Bishop Remembers His Grandmother's "Pigeon Tales"
 Virstee Howell Remembers Seeing Bears on the Square

Contents

13. Colorful Personalities 105
 Editor W.B. Townsend Didn't Worry About Typos
 Arthur Woody Was Georgia's First Forest Ranger

14. Exciting Events 114
 Train Robbers Were Captured Near Dahlonega in 1911
 A Foiled Bank Robbery
 Early Silent Movies Were Filmed in Dahlonega
 A Wagon Train Carried Dahlonega Gold for the Capitol Dome

Index 125
About the Author 128

Preface

Dahlonega, Georgia, is a historic and picturesque town located in the foothills of the Blue Ridge Mountains, seventy-five miles north of Atlanta. This book relates the story of this community's unique history as it was experienced by people who lived it or as it was told to them by their parents and grandparents. However, much of what is described within these pages is not unique to Dahlonega but is typical of how many people lived in the first half of the twentieth century, particularly in rural areas.

My parents came to Dahlonega in 1933, making me a native when I was born several years later. When I was growing up here during the '40s, I knew that Dahlonega was the site of the first major gold rush in the United States but not much else about the area's rich history. Back then people were more interested in the present and the future than the past. Old buildings were torn down without regret to make room for modern structures.

Quite frankly, I didn't enjoy history when I was in school. It was usually taught in terms of dry facts and dates, which I always had trouble remembering. It wasn't until I discovered historical novels that I became fascinated with the past, simply because I realized what history really is: the story of how people experienced life as it happened to them when and where they lived. Had I been born at that time and place, it would have been my story.

I married and moved away in 1956, but my roots remained deep in Dahlonega. My parents were still here, and we wrote weekly letters all the years my husband and I were away in the military. We enjoyed all the different places we lived around the country and world, but every time we thought about where we might like to retire, Dahlonega was always at the top of the list.

The Best of "I Remember Dahlonega"

After we moved back to Dahlonega in 1979, I was amazed how much the community had grown during the years we were away—and how it continued to change before my very eyes. I found myself reminiscing about the town I grew up in and also wondering what it was like farther back in time. I visited an elderly friend and got him talking about his experiences growing up in Dahlonega and things his parents and grandparents had told him. The stories he related were so interesting that I went home and wrote them down.

Family members who read Vernon Smith's stories suggested submitting them to our local newspaper, the *Dahlonega Nugget*. Editor Dorsey Martin was very receptive, but what really surprised us both was the response of the readers. As I continued to collect oral history for a weekly column entitled "I Remember Dahlonega," people stopped me everywhere I went to suggest someone else to interview.

Soon I was being urged to get the stories published in book form. Thinking that the material would be of interest only to people living in our immediate area, I decided to self-publish a volume entitled *I Remember Dahlonega; Memories of Growing Up in Lumpkin County* in 1990. It is now in its third printing and has been followed by three other volumes, all of which have been sent all over the country and are regularly purchased by visitors to Dahlonega.

I believe that much of the success of these books has been the result of letting people tell their own stories in their own words, using their own frequently colorful expressions. In some instances I have researched and written the story, so there are sections written in both the first and third person. In addition, I have written brief introductions to most chapters to provide the reader with background information about the stories to follow.

The material is diverse, but like a "crazy quilt," it all fits together into a colorful picture full of human interest and is often humorous as well as historic. Many of the old-timers I interviewed loved to relate funny stories!

At this point in history we human beings seem to be hungry to get in touch with our roots, perhaps sensing that we cannot understand who we are today without knowing from whence we have come. A line from Georgia's Historic Drama, "The Reach of Song," notes, "The most important thing is to remember where you came from. If you remember where you came from, it's going to be a whole lot easier getting where you're going."

Life was difficult for people who lived here—and elsewhere—during the 1800s and first half of the 1900s. They worked hard just to survive, and luxuries were nonexistent. Their existence probably seems much harsher to those of us accustomed to an easier lifestyle than it did to people who never knew the amenities we take for granted. Ironically, despite all our laborsaving devices, we seem to have less time to visit friends and help our

Preface

neighbors than people who worked from before sunup until after sundown, doing everything "from scratch."

Most old-timers admit to enjoying such modern conveniences as indoor plumbing but at the same time are nostalgic about the "good ol' days." They observe that although our houses are closer together today, our spirits seem farther apart. Have we "thrown out some babies with the bath water"?

As I reread all the stories told to me over the years, many by people who have since "passed on to glory," the dilemma was deciding which ones to include in this volume. My main criteria was material with universal human interest and as much humor as possible. I began the selection process with the story about Arthur Woody, Georgia's first forest ranger, because that was editor Jason Chasteen's favorite. If any of you readers feel the urge to write and tell me your favorite stories, I would love hearing from you.

Acknowledgements

A book is never written by one person. An author is merely a spokesperson for many others. This is particularly true of this book, for the words come from many different people who have shared their life experiences, wisdom and humor. My life has been enriched by all of them.

In addition to the people who shared the stories told in this book, there are those who have suggested neighbors and relatives to interview, people I would otherwise never have known about, and whose interest and encouragement have kept me writing.

If it had not been for the late Dorsey Martin, former editor of the *Dahlonega Nugget*, the first "I Remember Dahlonega" story would probably have been the last. Dorsey not only published the articles weekly, he featured them prominently and gave permission for me to use them in my books.

Retired postmaster Jimmy Anderson and the Dahlonega Gold Museum have been very generous in assisting me with information and loaning me photographs from their collections.

It was editor Jason Chasteen who suggested that I compile an edition of selected stories from all four volumes for The History Press to publish as *The Best of "I Remember Dahlonega."* Thank you, Jason, for your encouragement and editorial guidance every step of the way.

The most indispensable person is the man who helps this technologically challenged writer solve the mysteries of using a computer. He also proofreads what I write, makes helpful suggestions, carries heavy book boxes and fixes his own supper without complaint when I'm in the midst of a writing project. I am deeply grateful to my husband Amos for fifty years of love and support.

Introduction
Before there was a Dahlonega

Nearly a hundred years after Georgia was founded in 1733 as one of the original thirteen colonies, the mountainous northern section remained largely unsettled. Land west of the Chestatee River was still part of the Cherokee Nation. Although the Indians allowed white settlers to live among them and intermarry, they were determined to give up no more of their land.

In 1828 and during the following decade, the Cherokees were overcome by an event that shaped the destiny of the land as well as the Native American people: gold was discovered within the boundaries of the Cherokee Nation. Word spread like wildfire, and there was no stopping the hopeful hordes that poured into the region seeking their fortunes with picks and shovels.

In 1830 the State of Georgia claimed jurisdiction over the land and began surveying it to distribute by means of a land lottery. Lumpkin County was organized by an act of the Georgia legislature on December 3, 1832. The mining camp that was made the county seat of government the following October was named "Dahlonega," from the Cherokee word "Talonega," meaning yellow or golden.

1.
Gold Fever!

The first major gold rush in the United States began in north Georgia in 1828. The story goes that an early settler named Benjamin Parks was out hunting one day near the Chestatee River when he stumped his toe on a rock that glittered. Word soon spread that the rock contained a streak of gold, and hopeful prospectors began appearing by the thousands.

"The news got abroad, and such excitement you never saw," Uncle Benny Parks reminisced in later years. "It seemed as if the whole world must have heard of it, for men came from every state I had ever heard of. They came afoot, on horseback and in wagons, acting more like crazy men than anything else."

It has been estimated that as many as fifteen thousand miners were at work panning every river and branch within a fifteen-mile radius of Dahlonega during the height of the gold rush. They carried gold dust loose in their vest pockets or stuffed it into a goose quill. They measured it by how much would lie on the point of a knife blade. Many miners complained that merchants did not give them full value for the gold they used to pay for their supplies.

Coins were in short supply throughout the country; thus in 1835, Congress approved the establishment of a United States mint at Dahlonega to coin the gold being mined in north Georgia. Despite the difficulties of getting materials and equipment to the remote frontier area, the Dahlonega Branch Mint began operation in 1838 and continued until the outbreak of the Civil War in 1861. During that time it minted six million dollars in gold coins stamped with "D" for Dahlonega.

Gold was plentiful for a few years, but by 1849, the "easy gold" had been found. When news came that gold had been discovered in California, many Georgia miners determined to seek their fortune in the western gold

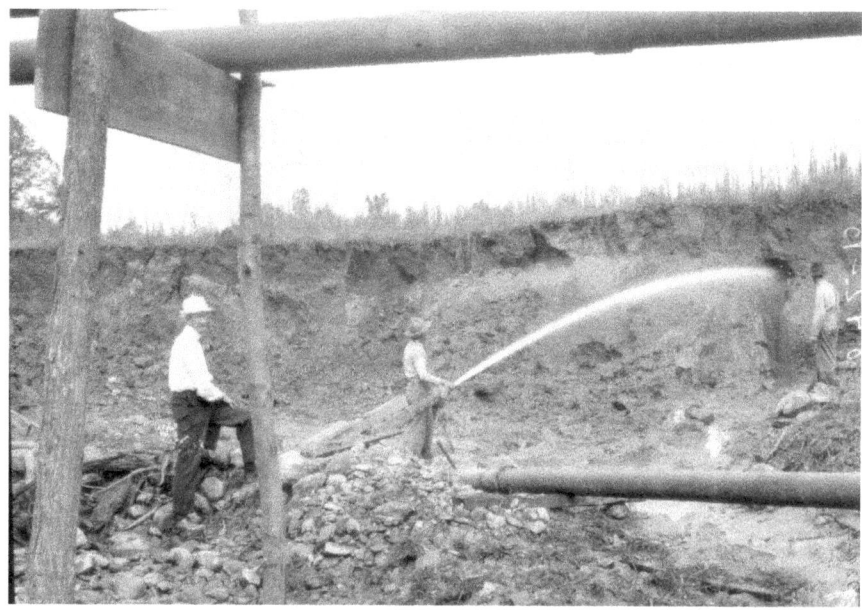

Using a water cannon to do hydraulic mining. *Courtesy of the Georgia Department of Archives and History.*

fields. Some of the "Forty-Niners" did not survive the long journey, but others returned bringing gold to be coined at the Dahlonega Mint. They also brought back new ideas for more efficient mining.

Mining companies were formed, large amounts of capital were invested in machinery, and mills were built to process the ore. Returning miners were particularly excited about the use of hydraulic mining—shooting great jets of water at the hillsides to tear away the earth and uncover gold buried beneath the surface. It was common to estimate the work of a water cannon as equal to the labor of ten men. The cannons were powered by water brought down from higher altitudes by means of a lengthy hand-dug aqueduct called the Yahoola Ditch.

Just as the aqueduct was being completed, shots were fired at Fort Sumter, and the country was plunged into the Civil War. Miners abandoned their picks and shovels for the muskets and rifles of war. Those who returned four years later discovered that flumes and trestles had rotted away. The lure of gold had not diminished, however, and men began repairing and extending the water ditch, replacing wooden trestles with iron tubes.

The Dahlonega Branch Mint never reopened, but gold mining resumed on a large scale with the aid of hydraulics and Northern capital. It culminated at the turn of the century with the formation of the Consolidated Gold Mining

Gold Fever!

Company, so named because it purchased a number of the richest properties. The company's huge plant, reputed to be the largest ever constructed east of the Mississippi River, included a 120-stamp mill and chlorination equipment designed to save 95 percent of the gold at minimum cost.

By 1906 the Consolidated Gold Mining Company had gone bankrupt due to over-extension and poor management. Its impressive buildings stood idle and gradually fell into ruin. Some local prospectors continued to mine on a small scale, but gold mining as the area's principal economy had come to an end.

For years visitors to Dahlonega asked, "Where can we see a gold mine?" only to be told that the mines were all on private property and unsafe as well. One of the long-abandoned tunnels of the Consolidated was opened for tours in 1991 and remains a popular attraction. Bearded guides wearing hard hats with lanterns take visitors underground to see how gold was mined a century earlier. The tour includes the "Glory Hole," a yawning 250-foot vertical shaft. The large rock pillar in the center still has a rich gold vein running through it but had to be left intact to keep the walls from collapsing.

Following the underground tour, visitors may choose to pan for gold in the Consolidated Mine's panning boxes. The Crisson Mine also offers opportunities to pan for gold and gemstones and has a working stamp mill on display. The ore at both mines is rich enough for most panners to find at least a few flecks of gold in the bottom of their pans.

John Crisson Remembers His Gold Mining Ancestors

> Elijah Crisson came here from North Carolina when this was still Cherokee territory. Even though Benjamin Parks had not yet stumped his toe on a gold rock and started the gold rush in this area, I've always believed that great-great-grandpa Elijah was mining for gold and keeping his mouth shut!
>
> Things apparently started getting too crowded for Elijah once gold was discovered here in 1828. He headed west with his oldest son and planned to send for the rest of the family once he got settled in a new location, but they never heard from him again.
>
> William Reese Crisson was twelve years old when his father disappeared. He helped clear the land and build Lumpkin County's first log courthouse in 1833. W.R. went to California by way of South America in 1850. I still have the tools he took with him. When he returned a few years later, he is reported to have said you could do better gold mining here than in California.
>
> W.R. published a pamphlet on mining in 1875, in which he gave an eyewitness account of seeing J.J. Findley hand-mortar a gallon bucket of

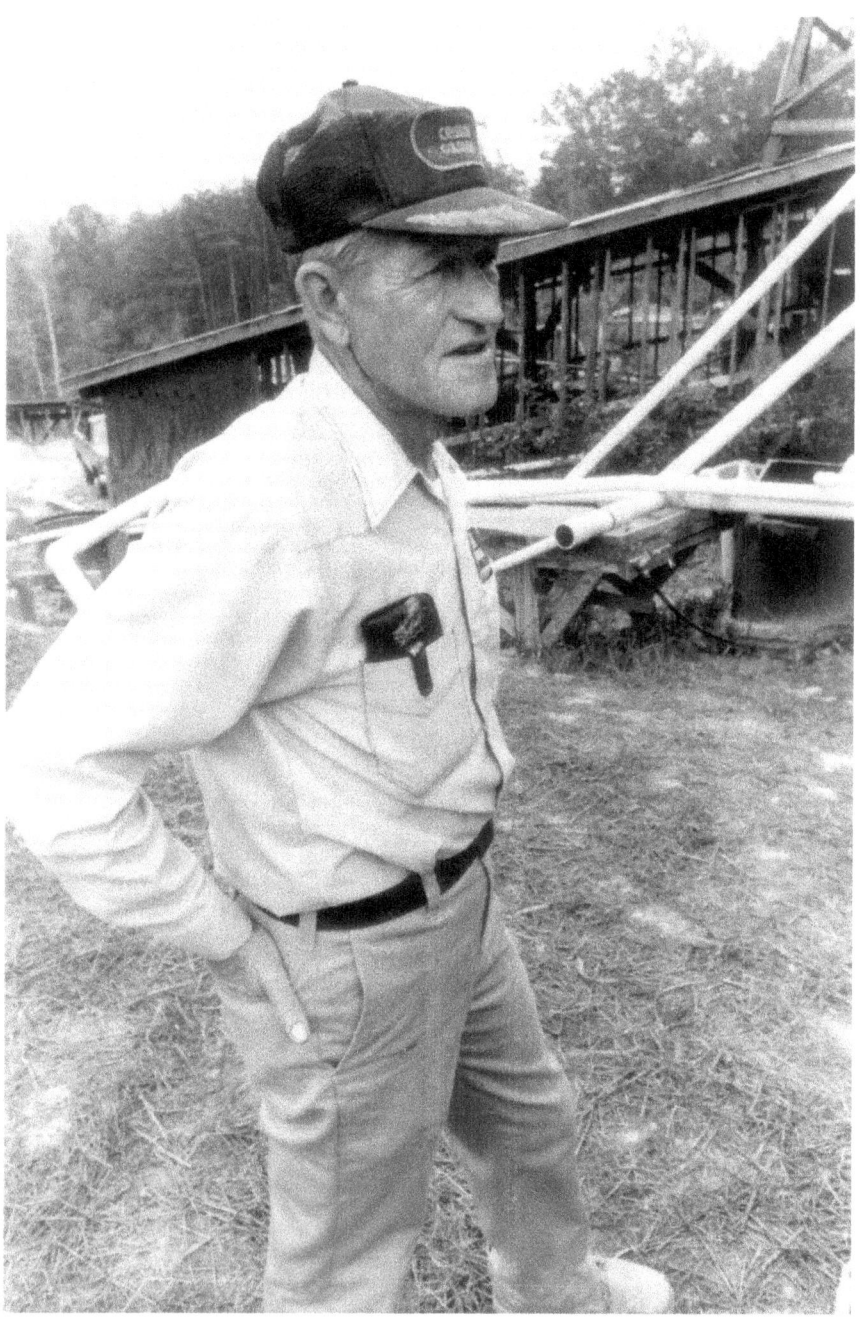

John Crisson at the Crisson Mine, property purchased by his grandfather, E.E. Crisson in 1833. *Courtesy of the Dahlonega Gold Museum.*

Gold Fever!

ore taken from the Findley Mine. When he'd finished, there was a half-gallon of pure gold. That's rich ore!

Grandpa E.E. Crisson bought this property [the Crisson Mine located on today's Morrison Moore Parkway] in 1833 and started mining here. In addition to running a ten-stamp mill, he farmed and ran a general store. E.E. married Mathilda Fields, the daughter of Boling W. Fields, who discovered the "Boley" Fields pocket in 1857. The Chestatee River had gotten real low, and he saw a seam of gold in a rock sticking up out of the water. He went back to town and quietly got mining rights to the property.

My daddy, Reese Crisson, was born in 1907, the same year W.R. died. The Consolidated Gold Mining Company went broke the previous year, and he said it failed because the operation was too blamed big. The mill had 120 stamps and was reputed to be the largest gold mill ever built east of the Mississippi. They brought in out-of-state experts and wouldn't listen to the local miners, who knew a lot more about mining in this area. I've been in the tunnels they worked, and what they did just doesn't make any sense.

Even though gold mining on a large scale came to an end when the Consolidated folded, the Lockhart and several other underground tunnel mines were still being worked up until World War II. Mining came to a standstill then because they couldn't get explosives and other materials needed for the war effort.

Mining was never resumed after the war because Roosevelt had frozen the price of gold at thirty-two dollars an ounce and prohibited private citizens from owning more than twenty ounces of unrefined gold. Furthermore, the U.S. had gone off the gold standard to silver. But you can still go in any of the old mines in Dahlonega today and find richer ore than is being mined in Africa. The problem is that all the "free gold" is played out. What's left is "sulfide gold." That means the gold is locked up inside ore so hard that even water cannons couldn't tear it apart. Besides, hydraulic mining was outlawed in the '40s.

After I started mining here in 1975, I discovered the book that great-grandpa W.R. wrote about gold mining back in 1875, and I was amazed to learn that I had come up with the same concepts he developed a hundred years earlier. He implemented part of his plan but lacked the capital to do so fully. That's still the problem today. A number of folks have tried to mine without sufficient capital and gone broke. There aren't any short cuts to gold mining.

The Best of "I Remember Dahlonega"

Marion Boatfield Remembers Gold Mining Being Like Gambling

Papa [Jesse McDonald] was a gold miner, and you might say I was raised in a mine. What one member of our family was into, we were all into. Gold mining is just like gambling—one day you hit a strike and the next day you don't find a thing—so we mostly farmed in the summer to put up food to eat and mined in the winter.

We used all the different methods of mining—hydraulic, placer, sluice boxes, pans—and Papa had a little "Tom Thumb" stamp mill to process the ore we took out of the Standard Mine. He was a real gold miner who knew just about everything there was to know about mining. Mama [Clara Satterfield McDonald] could find gold even when Papa couldn't. She loved to prospect and was always cracking rocks as long as she lived.

When I married John Boatfield, he started helping Papa out in the mine. He had never mined before, but his granddaddy [Frederick D. Boartfield] was one of the earliest workers at the Dahlonega Mint when it began operation in 1838. He came here from Philadelphia but was originally from Holland. He met and married John's grandmother after he came to Dahlonega. The "r" in his name was gradually dropped, but the name on our marriage license is spelled "Boartfield."

In 1934 John and I moved across Yahoola Creek to the Singleton Mine and mined it for the owner, "Doc" Arnold. It had a small stamp mill and was paying good for him even though the Consolidated Mines (which included the Singleton and several others) had gone broke and shut down in 1905. We moved into what used to be the Consolidated's assay office, where they tested the ore to see how much gold was in it.

The Consolidated Mines was just too big an operation for the amount of ore available. There's nothing left today except the big smoke stack and the massive rock foundations of the mill. There are still cuts and tunnels all up and down the hillside, but they aren't safe to go in. When a mining company bought some of the property a few years ago, they wanted me to go in one of the tunnels with them, but I told them, "I'll stay out here and tell 'em where you're at." They were lucky they got out without the whole thing caving in on them.

When World War II came along, the price of mercury [used in processing gold] got so high that it cost more than the gold did. That put

Gold Fever!

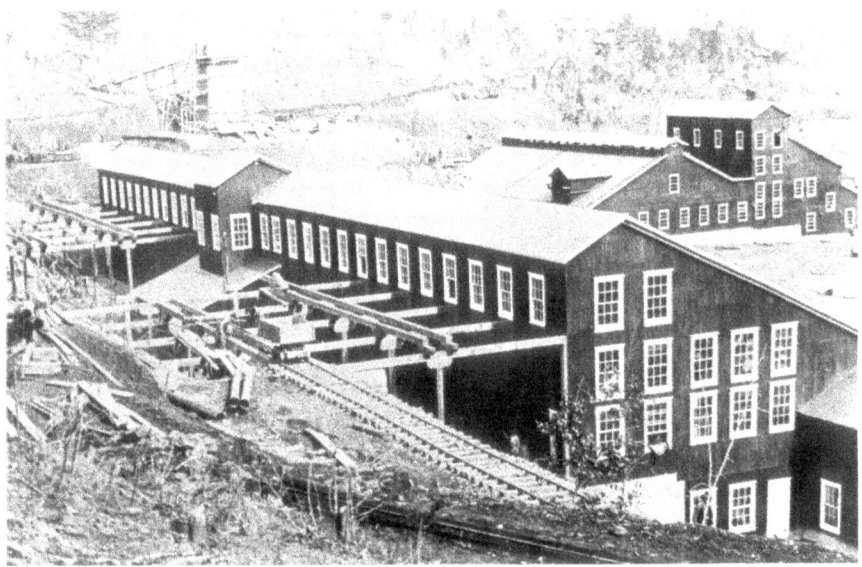

The Consolidated Gold Mining Mill under construction in 1900. *Courtesy of the Dahlonega Gold Museum.*

a stop to just about all the mining in this area, and a lot of the machinery was pulled out for scrap metal. John and I stayed on at the Consolidated as caretakers for "Doc" Arnold, and we farmed.

There's still plenty of gold around here, and there always will be. They never will get it all. The old-timers got all the easy gold, and what's left is deep and hard to get at. I haven't done any looking lately because I'm not as young as I used to be, but I'd love to come along behind the big machines that are cutting down the hillside to build the new road. They have to be plowing up veins of gold all the time. Once you catch gold fever, there ain't no cure for it!

Robert Jenkins Remembers Finding G old Nuggets on the Public Square

I remember picking up many a gold nugget on the Dahlonega Square before it was paved. Big grains of gold collected in potholes after a good rain, especially on the south side. I never found much on the other side

The Best of "I Remember Dahlonega"

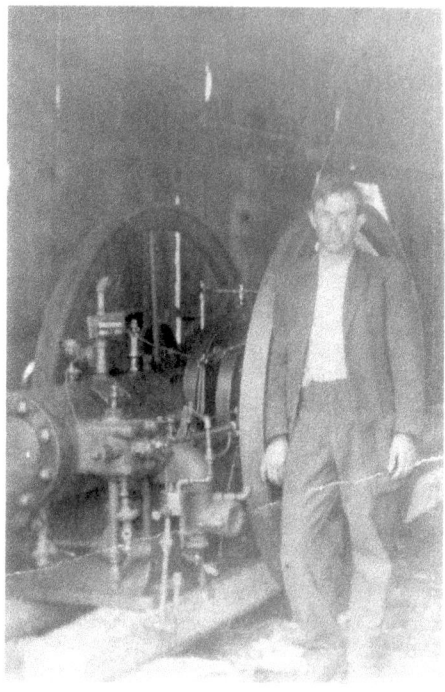

Tom Jenkins standing beside gold processing equipment. *Courtesy of the Dahlonega Gold Museum.*

of the courthouse. My granddaddy, George Washington "Wash" Jenkins, mined right in a city street back in 1894.

My daddy, Tom Jenkins, and his brothers Bill and Luke used to mine Tanyard Branch where the college parking lot is now. They did a lot of mining on Crown Mountain, too. Daddy found enough gold to buy his home, and we always had plenty to eat back when lots of folks went hungry. I remember seeing Daddy pretty nearly fill a pan with gold in one day.

Because Daddy knew where to look to find gold, there used to be an ol' guy who followed him to find out where the good places were. Then he would go to the owner of the land and offer him a bigger percentage of the gold if he'd let him work that area instead of Daddy. Miners gave anywhere from 10 percent to 20 percent of the gold they mined to the owner of the property.

I've been a gold miner all my life, and I've found quite a bit of gold in my time but nothing like what Daddy found. All the folks who came to pan at my Gold Miners Camp always found some color in their pans if they knew how to keep from losing it. That's because I know where to get the ore. There's still gold in these hills, but the big part of mining is over for Lumpkin County because they're building right over the gold.

C.C. Davis Remembers a Mining Tunnel

In 1932 my father [C.C. Davis] and Uncle Jody Townsend undertook the project of completing a tunnel originally started back in the 1890s to divert the Etowah River. The purpose of it was to make about a mile-and-a-half of the original riverbed available for gold mining. Men worked from both ends with dynamite and jackhammers run with gas-driven air compressors until they finally met in the middle. After all that effort and expense, the exposed riverbed actually yielded very little gold. The tunnel is located near the Lumpkin-Dawson county line, and some water still flows through it.

Ross Adams Remembers Feeding the Stamp Mills

I started working in the mines when I was about seventeen or eighteen. My job was usually shoveling ore with a square-bottomed shovel to feed the stamps that pounded it into fine dust. Then it went into a sluice box to be washed. The gold was heavier and fell to the bottom, where it was caught on copper plates coated with quicksilver.

Every week or so we would have what was called a "cleanup" to get the gold. First, the mercury plates were scraped with a piece of hard rubber. Then the mass of gold and quicksilver was put into a round iron container and heated in the blacksmith's forge. The heat made the quicksilver boil out and caused the gold to melt and run together so that it came out looking like a half-pound of yellow butter. Sometimes it would weigh six or seven pounds, and I remember throwing a good-sized ball of gold back and forth with another fellow like we were pitching a baseball!

2.
The Cherokees Called North Georgia "The Enchanted Land"

Long before the discovery of gold, the mountains of north Georgia were home to the Cherokee people. They loved and respected the area they called "The Enchanted Land," which nurtured them with its abundant animal and plant life. These Native Americans were hunters but also an agricultural people who grew such crops as corn, wheat, cotton, potatoes and tobacco. White settlers were permitted to live among them and intermarry, and as a result of this contact, many Cherokees adopted the Christian religion.

Many Cherokees were also literate. In 1821 Sequoya developed a syllabary for the Cherokee language so his people could "talk on paper" like the white man. Beginning in 1828, a newspaper called the *Cherokee Phoenix* was published at the capitol of New Echota by a Cherokee named Elias Boudinot. It was printed both in English and in the newly invented Cherokee characters.

In 1802 Georgia, which once extended all the way to the Mississippi River, had ceded her lands west of the present boundary to the United States government on condition that the Indians would be removed from the state. Impatient with the government's slowness in carrying out their part of the bargain, settlers and gold miners began moving into the area in increasing numbers.

In 1830 the laws of the State of Georgia were declared effective throughout Cherokee territory, superseding the existing Indian government. Teams of surveyors partitioned the area into land lots to be distributed to white settlers by means of a land lottery.

Even though most Cherokees were strongly opposed to leaving their homeland, some of their leaders recognized the futility of trying to hold out against the overwhelming flood of white intruders. In 1835 these leaders

The Cherokees Called North Georgia "The Enchanted Land"

signed a treaty agreeing to surrender their Georgia land for an equivalent amount in the West and five million dollars. Despite bitter arguments that these few were not authorized to speak for all the Cherokee people, the treaty was enforced by the U.S. government. It stipulated that all Indians must be gone by May 23, 1838, and General Winfield Scott was charged with enforcing their removal.

The Trail of Tears for Cherokees in the area around Dahlonega began at a holding area called "The Station," located near the mining community of Auraria. They later joined others at Ross's Landing near present-day Chattanooga. Although some wagons were provided, many walked the entire distance to Indian Territory in Oklahoma. The last groups to leave suffered greatly from being caught in winter snow and ice, and many died on the arduous journey.

As a people the Cherokees were separated from their homeland forever, yet they can never be forgotten because of the rich legacy of place names they gave to the rivers, mountains and other sites in north Georgia. Mellifluous words like Chestatee, Etowah, Nacoochee and Amicalola remain part of the enchantment of this area even today.

Walker Dan Davis Remembers His Cherokee Ancestors

The Davis family traces its ancestry back to a full-blooded Cherokee woman of the Long Hair Clan, who married a Scottish immigrant named Sir Ludovic Grant in the early 1700s. Their great-granddaughter, Rachel Martin (1788–1843), was a spokesperson for the Cherokees, and her name is mentioned in history books as negotiating treaties between the Cherokees and the U.S. government. Rachel married Daniel Davis in 1808, and they came to this area not long afterward. They raised ten children.

Daniel and Rachel had large holdings of land in north Georgia in the early 1800s, but the Treaty of 1817 required them to give up all but 640 acres located near the Davis home place on the Etowah River. Daniel was one of only five people in Georgia permitted to retain and live on a 640-acre tract referred to as a "reservation." This allowed the family to remain in Georgia instead of being removed to the West.

When the State of Georgia seized their land to raffle in the land lottery, our Davis ancestors fought hard to keep it. They lost it when the federal court failed to enforce the Treaty that granted them the reservation, but they were later able to buy back some of it from the lottery winners. My family still holds some acres that were part of the original Federal Cherokee Reservation.

Although Rachel and her family were not required to go on the Trail of Tears, her son Daniel voluntarily went to Indian Territory to claim land available to those having Cherokee blood. He died there of yellow fever and is buried in Briartown, Oklahoma. His wife Gabrilla was pregnant with my grandfather, Walker Dan Davis (1878–1955), and wasn't strong enough to make the trip with him.

Many Cherokees hid out during the Indian removal so they wouldn't be forced to leave the area. Since there weren't supposed to be any Indians left here after the Trail of Tears, those who stayed behind had to change their names and live like white settlers. Native Americans were not officially allowed to own land, vote, hold public office, or attend public schools until the old law was repealed in the 1960s, but it hadn't been enforced since the early 1900s. My grandfather, for whom I was named, was on the Lumpkin County Board of Education during the 1940s.

Some Cherokees came back to north Georgia in the 1860s and lived on Daniel Davis's land along the Etowah. Many of the Cherokees in this area are descendants of Rachel Martin Davis and consider themselves to be a tribe. Even though modern-day Cherokees may be blond-haired and blue-eyed, we still consider ourselves to be Indian and are proud of our heritage as Native Americans.

My wife Dola and I enjoy putting on our traditional deerskin clothes and giving programs about the Cherokees to schoolchildren and various organizations. We show baskets made of river cane from the old Davis home place, and I demonstrate a cane blowgun used for hunting small game.

Dola and I are active in the national Trail of Tears Association and helped start a Georgia chapter in 1997. We're working with others to identify and mark sites along the nine-state route and to promote public awareness about the historic Trail.

J.B. Jones Remembers Growing Up in Frogtown

My great-grandfather, William Jones, got permission to enter the Cherokee Nation as early as 1815, and he settled in a fertile valley north of Dahlonega called Frogtown. The name "Frogtown" is derived from "walasi-yi," which means "frog place" in Cherokee. Maps made by surveyors in 1820 show Frogtown Trail running through what the Indians and early settlers knew as Frogtown Gap (today Neel's Gap).

There was also a Cherokee settlement known to the whites as Frogtown. William Jones wrote letters to historian Lyman Draper in the early 1870s

The Cherokees Called North Georgia "The Enchanted Land"

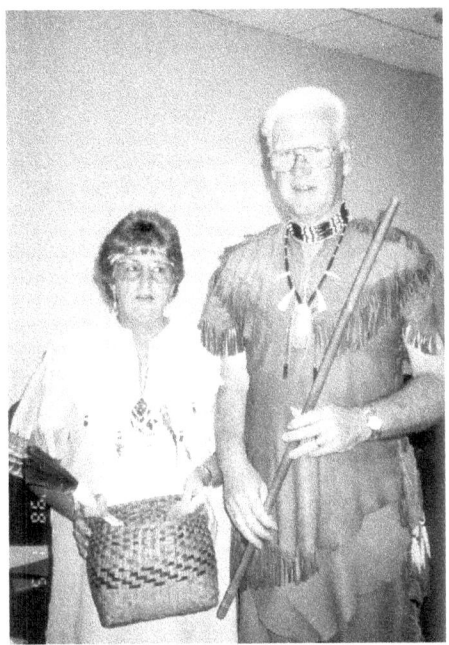

Walker Dan and Dola Davis displaying Cherokee clothing and artifacts. *Courtesy of the author.*

describing the village townhouse on the east bank of the Chestatee River near where today's Damascus Church Road crosses the river. In one of his letters great-grandpa William wrote, "From what I can learn, Frogtown was the big or center place they all met to transact business."

William had seven sons and three daughters. Four of his sons went to the California gold rush, and three of them never returned. Two died en route, and one settled on the West Coast. Sam, my grandfather, fought with the "Blue Ridge Rifles" in the Civil War. He got a boot heel shot off once and a lock of hair another time, but he was never wounded.

My dad was named for Judge J.B. Jones, who was admitted to the Georgia Bar in Gainesville in 1885, and I was named for him. Daddy had four sons by his first wife (Ora Sutton) and six children by his second wife, Rada Armour, who was my mother. Mama had jet-black hair and dark skin and eyes because she was part Indian. The old folks say I was the first brown-eyed male in the family since the Joneses came over from England.

Mama had a lot of Indian ways, though she never talked about being Indian or why she did what she did. For instance, she would burn a big brush pile in the spring. After it cooled down, she put four logs around it and prepared her seed bed. She was sterilizing the soil and killing the weed seed, but I never understood what she was doing until I was grown.

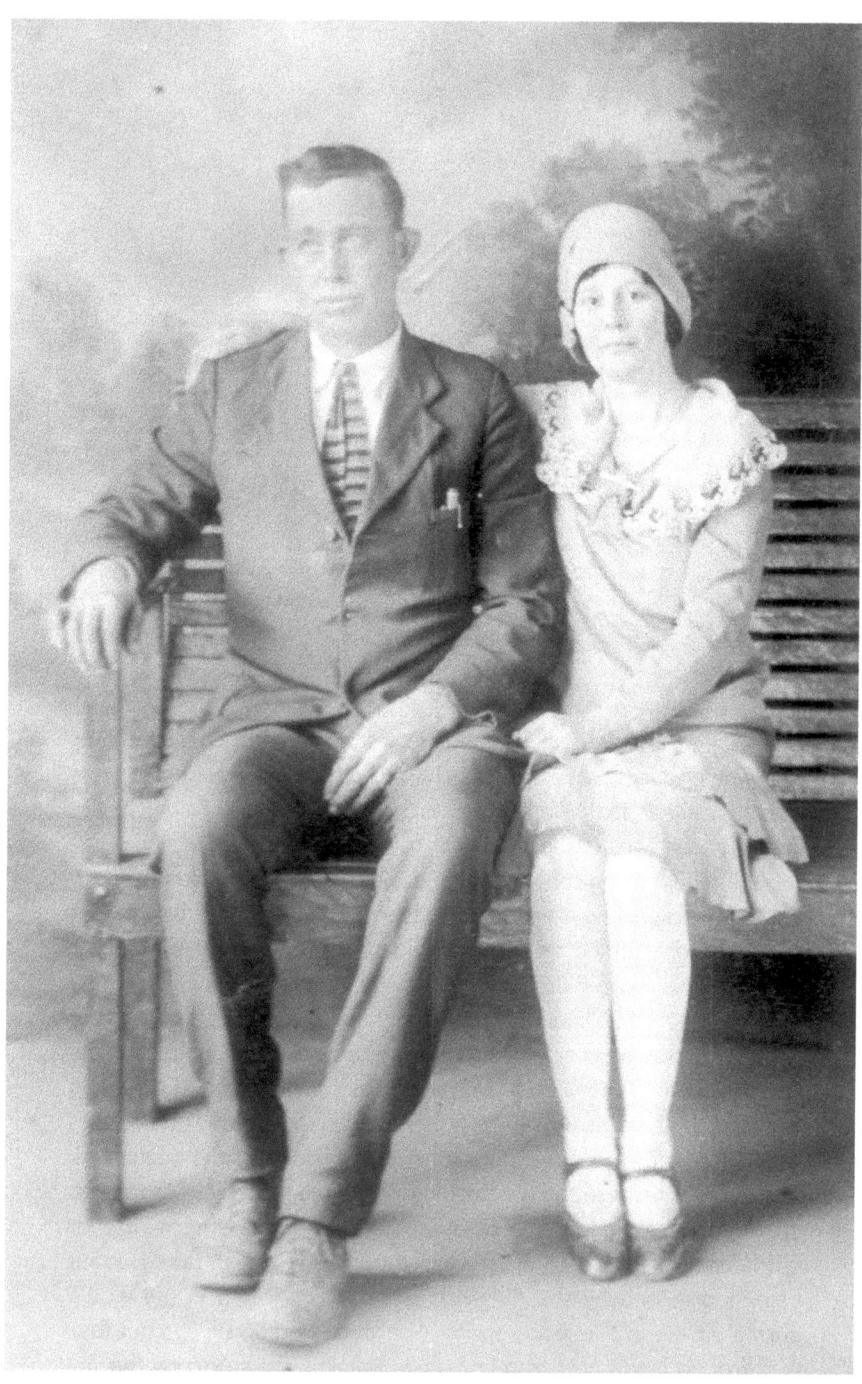

J.B. Jones and Rada Armour Jones ca. 1930. *Courtesy of J.B. Jones.*

The Cherokees Called North Georgia "The Enchanted Land"

She knew lots of Indian remedies and always gave us a concoction of herbs every spring to clean our livers. If we got a bee sting, she taught us to chew up ragweed or tobacco leaves and put our spit on the wound. She cured headaches by brewing a tea made from willow and treated diarrhea with a strong tea made from the inner bark of a red oak tree.

Mama believed in killing only to eat but not for sport, and she was dead set against poisoning anything. I bought some strychnine one time to poison the crows that were eating up my corn. She followed me around and nagged me until she finally made me break the can and burn it. Another thing she was fussy about was making sure all meat was completely bled before used.

Growing up in Frogtown was an experience. We got a bath every Saturday night whether we needed it or not, and we always fought for the privilege of going first, since we all had to use the same water!

The first school I attended was a one-room country school. In those days only the good kids got to go to the spring to get water and tote in the firewood, and you had to be a "B" or better student to have any hope of dusting erasers! After I started high school, I stayed in town during the week with Dad's younger sister, Ada Jones.

When the Korean War broke out, there were thirty in the draft call from Lumpkin County, but only two of us were accepted. Johnny Abercrombie, who only went through the sixth grade, was put to working with guided missiles, while I ended up in the infantry. Later I was sent to White Sands Proving Ground in New Mexico. There I talked with Werner von Braun himself, but I couldn't call home to tell anybody about it because there were still no telephones in Frogtown. We got telephones in Frogtown in 1969, the same year that Neil Armstrong walked on the moon!

3.

Auraria:
From Boomtown to Ghost Town

The gold region of north Georgia was legally closed to intrusion as surveys were being made for the upcoming land lottery. However, so many miners ignored the law that the Georgia Guards in charge of enforcing it largely gave up trying to disperse them.

In June of 1832, William Dean defied the "no man's land" legal status by building a log cabin on a ridge between the Chestatee and Etowah Rivers. Emboldened by his example, other squatters followed suit, including Nathaniel Nuckolls, who erected a tavern and a small log hotel. The village that sprang up in the area was known as Nuckollsville, but most people thought of it as "Knucklesville" because of the frequent fist fights that broke out among the miners. The name was later changed to "Auraria," from the Latin word meaning gold.

When Lumpkin County was created in December of 1832, everyone expected Auraria to become the seat of government. Fate, however, determined otherwise. The man who won that land lot in the lottery obtained it fraudulently by claiming to be head of a household when he was, in fact, a bachelor. Since the case was likely to be tied up in court for months and a county seat was needed immediately, the court selected another site six miles away.

The citizens were indignant, some even declaring that Auraria should secede from the rest of the county, but the court refused to reverse its decision. The original mining community began to decline as businesses and county offices began moving to the new location called Dahlonega.

The gold mining boomtown that reportedly had a population of ten thousand at the height of the gold rush still boasted over four thousand inhabitants in 1848. When news came that gold had been discovered in

Auraria: From Boomtown to Ghost Town

Ruins of the 1830s-era Graham Hotel in Auraria. *Courtesy of the Dahlonega Gold Museum.*

California, many Georgia miners headed for the new gold fields, causing Auraria's remaining population to plummet dramatically.

Still described as "a prosperous little village" as late as 1932, Auraria eventually became a "ghost town." Only abandoned mines and the fallen-in ruins of the 1830s-era Graham Hotel remain of the gold mining boomtown originally known as Nuckollsville.

The community is remembered today not only for its historical significance but also for two remarkable women who lived there: Agnes Paschal during the 1800s and Amy Trammell in the 1900s.

AGNES PASCHAL WAS AURARIA'S "ANGEL OF MERCY"

Auraria was a rough-and-ready gold mining camp when a young attorney named George W. Paschal opened a law office there in 1833. He was soon joined by three siblings and his fifty-eight-year-old mother, Agnes—a remarkable woman who soon became affectionately known in the community as "Grandma" Paschal. Whenever there was strife and conflict in the community, she was the peacemaker who poured oil on the troubled waters, and she turned many lives around with her kind motherly advice.

The Best of "I Remember Dahlonega"

The Paschal family purchased Nathaniel Nuckolls's small log hotel and operated it successfully, despite the fact that Agnes would allow no alcohol to be served in her establishment. U.S. Senator John C. Calhoun and his mining partners, Henry Clay and Farish Carter, made their headquarters at the Paschal Hotel whenever they were in town.

Soon after her arrival in Auraria, Agnes Paschal began raising funds to build a church in the rowdy mining camp. She put her own name at the top of a subscription list and carried it from door to door, asking for donations. When enough money had been raised, she engaged workmen to erect a log church, which was organized in 1833 as Antioch Baptist Church.

Despite Mrs. Paschal's diligent efforts, religion had an uphill struggle in Auraria. Drunken miners delighted in disrupting church services, making it difficult to keep a full-time preacher. Snow and ice accumulated on the roof of the church in 1834, causing it to collapse. Undaunted, Agnes moved services to the dining room of the Paschal Hotel.

Medical doctors were scarce in the region, so when the dreaded "summer fever" struck many of the miners and their families, Grandma Paschal ministered tirelessly to those afflicted. She had little use for standard medical treatments of the day, such as bleeding the patient and applying leeches. She relied instead on the use of herbs, well-ventilated rooms and patient nursing, with herself as nurse. The village's crude houses had been hastily constructed without any attention to ventilation, and all the shade trees had been cut down for firewood, making it difficult to tell whether patients were burning up from fever or from oven-like indoor temperatures.

Once when this dedicated woman left her warm bed to go and tend a sick member of the community, the horse she was riding balked and threw her over his head. She picked herself up and continued on her mission of mercy, but her right arm was badly broken. She set it as best she could by herself, but by the time she got home, the arm was too swollen to reset. It continued to pain her for the rest of her life, but she didn't let it stop her from helping others. "It's better to wear out than rest out" was her motto, and she frequently commented that she didn't wish to live any longer than her life could be useful to others.

Agnes believed that the South was making a serious mistake in seceding from the United States. She foretold to all who would listen that "the remedy sought by the South would surely destroy the institution which it was endeavoring to save." She had grandsons fighting in both the Union and Confederate armies, and she prayed daily that they would not meet in battle. She grieved deeply when her beloved grandson Egbert was mortally wounded at the Battle of Resaca.

Auraria: From Boomtown to Ghost Town

When Agnes Paschal died in October of 1869 at the age of ninety-four, she was described as "an angel of mercy" who had ministered to the needs of the sick, performed the necessary offices for the dead and who lived "but to benefit others." Her son George recalled her as "ever cheerful and hopeful," with "an encouraging word for everyone." In 1871 he published a book about her life entitled *Ninety-Four Years; Agnes Paschal*.

AMY TRAMMELL WAS AURARIA'S LADY GOLD MINER

Amy Trammell is gone from the gold fields of Auraria, but she is far from forgotten. She was such a remarkable woman that she became a legend in her own day, and the legend lives on in the hearts and minds of all who knew her.

Amy certainly never set out to become a famous lady gold miner. She was born Amy Pinson on Christmas Eve of 1907 and grew up on a farm in Hall County. She walked two miles to attend a one-room school near Murrayville when she wasn't helping out on her father's farm. That's where she met a gold miner from Auraria named Bill Trammell.

The schoolteacher boarded near the school during the week but went home to Auraria on weekends. Her brother, frequently accompanied by his friend Bill Trammell, came to get her, and, since Amy lived in the same direction, they gave her a ride home every Friday afternoon.

When Bill Trammell learned that Amy had to walk several miles to attend church, he offered to drive her the following Sunday. She was surprised when he showed up in a new car instead of a wagon or buggy. Even though Bill was thirteen years older than she was, their friendship blossomed, and they were married in the fall of 1925 when she was seventeen.

Amy had no interest in gold mining when she became Mrs. Bill Trammell and moved to Auraria. While Bill was out panning for a living, she was raising their three boys and nursing sick people in the community. During an outbreak of typhoid fever in Auraria in the 1930s, Amy went from house to house doing what she could to relieve the suffering. Bill's brother died, and his mother was in bed for fifty-five days.

As the Trammells watched Auraria dwindle down to a ghost town, Amy listened to the area's old-timers tell what life had been like in the past. Fascinated with the history that had taken place there, she began writing it down to preserve it. She wrote,

The Best of "I Remember Dahlonega"

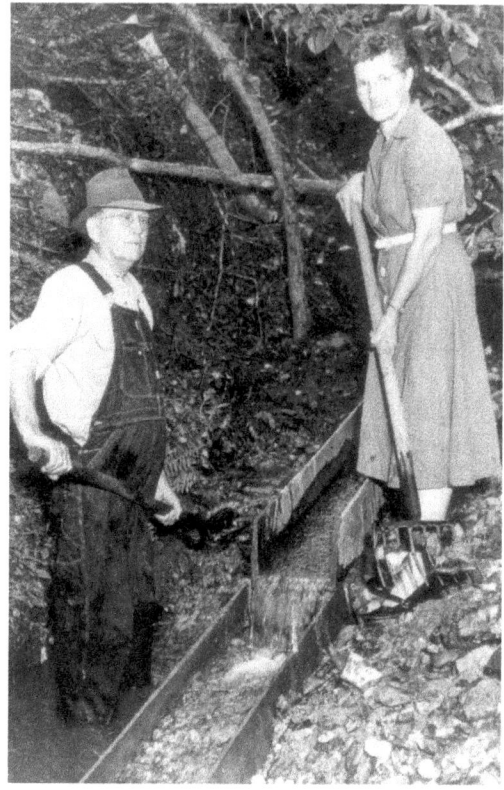

Amy and Bill Trammell working a gold mining sluice. *Courtesy of the Dahlonega Gold Museum.*

When I came here to live in 1925, old houses could be seen most anywhere. My father-in-law, who was born here in 1849, taken me to many old places almost ready to fall down. I saw old houses with no floor, and he said just the bare ground was the way many of the old people lived. In one old cabin…we could see what is called slabs of lumber, the flat sides turned up. He said that was for their beds. Glass windows were unknown.

After listening to the old gold mining stories and seeing Bill's excitement when he came home after a good find, Amy eventually caught "gold fever" herself and started going out with her husband to prospect. He taught her everything he knew about mining, and they worked together for the next thirty-five years. They sold their gold to nearby stores, where it was weighed on gold scales used a hundred years previously, and they raised their family on the income it provided. Bill always used a handmade pan that his grandfather brought with him to Auraria in 1835.

Auraria: From Boomtown to Ghost Town

If they found gold in a stream, they knew it was coming from a vein in a nearby hill. Beginning at the foot of the hill, they started skimming the top of the ground looking for "color." When their pans started showing flecks of gold, they began digging into the red clay looking for the vein. "Sometimes a vein wouldn't be no bigger than a pencil," Amy wrote. The widest vein she ever worked was two inches.

One day Bill called for Amy to come out of a tunnel they were working because he had a premonition there was going to be a cave-in. She joked that if that happened, at least he wouldn't have to pay to bury her, but she obeyed his instruction. Later, when he left to do some prospecting on the other side of the hill, Amy began digging on the surface. She had only dug down a foot or so when the ground gave way and she fell into the tunnel Bill had warned her about. It kept caving in, and she struggled for two hours trying to get out.

That was only one of several close calls Amy had while working underground. Another time she looked down and saw a poisonous snake coiled up just below her feet. She called up to Bill, who got his rifle out of the truck but was afraid to fire it because of the close quarters. "Hit's too close to your head," he told her. "Well, it's death either way, and I'd rather get it in the head than in the foot because it'll be a quicker death," she replied. She flattened herself against the bank while he shot past her and killed the snake.

When Bill fell ill and became unable to do the hard work of mining, Amy did it by herself for sixteen years to make money to buy his medicines and pay his medical bills. She mined even on bitterly cold days when the ground was frozen and she had to keep warming her hands at the fire she built nearby to keep from getting frostbite.

After Bill's death in 1966, Amy continued to mine alone for three years. When she was asked to become a hostess at the newly opened Gold Museum in Dahlonega, Amy delighted in explaining the gold mining process to visitors. She enthralled thousands with her personal knowledge and experience.

Like her husband, Amy had a sixth sense about some things and foresaw her own death. Early in December of 1989, she told a friend that she knew she was going to die on her eighty-second birthday. Even though nobody wanted to believe her, Amy's prediction proved to be correct.

Amy Trammell left her beloved community of Auraria and its abandoned gold mines for the heavenly kingdom on her eighty-second birthday, December 24, 1989. If the streets of heaven are indeed made of gold, Amy is undoubtedly happily digging them up and panning them!

4.
They Wore Both Blue and Gray

There were few slave owners in the mountains of north Georgia, and Lumpkin County had many Union sympathizers. Both of its delegates to the Secession Convention held in the capitol at Milledgeville in January of 1861 voted against secession. Five hundred men from Lumpkin County served in Confederate and State units, but there were another hundred whose consciences led them to join Union forces. Families and neighbors were divided by their opposing loyalties.

The Confederacy seized the United States Mint in Dahlonega and closed it, relocating the gold on hand to other locations. In 1864 and 1865 Dahlonega was the headquarters for several militia and Confederate reserve forces, which used the courthouse as a military prison.

Due to its location in the mountains, Dahlonega escaped becoming a battleground and suffering the destruction of Sherman's "March through Georgia." Skirmishes did take place in the area, and women and children were frequently terrorized by roving bands of outlaws who took advantage of their menfolk's absence by stealing everything of value.

After Lee's surrender at Appomattox in 1865, Federal troops were stationed in Dahlonega for three years. A large detachment took possession of the abandoned U.S. Mint and made it their barracks.

After the war ended, veterans continued to hold annual reunions as long as there were any alive to attend. They reportedly fought the battles all over again verbally. Of the Civil War stories that have passed down in local families, many have to do with the difficulties experienced by the wives and children struggling to survive without the man of the family.

They Wore Both Blue and Gray

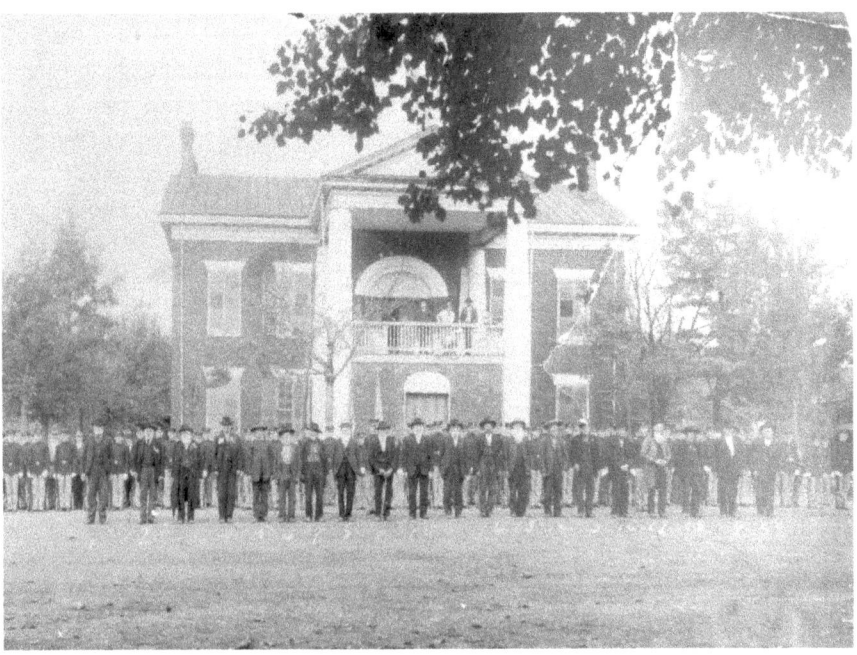

Civil War veterans in front of the courthouse on Confederate Memorial Day 1909. *Courtesy of the Georgia Department of Archives and History.*

CIVIL WAR STORIES

Elmer Garrett

One of my granddaddies fought for the South and the other fought for the North during the Civil War, so I'm not sure what that makes me. It reminds me of a story my daddy used to tell about some ol' guy who was set upon by armed bandits right after the war.

"Are you Democrat or Republican?" they demanded. When he told them he was a Democrat, they like to have beat him to death.

Not long after that he was captured again by a bunch of roughnecks who demanded to know his political leanings. This time he was quick to say he was a Republican, only to discover that once again he was in the wrong camp.

The third time it happened, he had learned his lesson. When they asked if he was Democrat or Republican, he told them, "I'm whatever you are!"

My mother's father was John Sheriff from Dawson County, and he was the one to fight for the Confederacy. My other granddaddy, Luther Garrett, was originally from Ireland. He believed he should fight for the North, so he made his way through the mountains to Tennessee to join up with Union troops.

The Best of "I Remember Dahlonega"

Marcella Crane Gibson

My daddy [William James Crane, 1833–1926] went plumb through the Civil War and never got a scratch, except his arm got infected from a typhoid shot they gave him. It stayed "pore" the rest of his life, but he never let it stop him from doing anything. I never heard him talk much about the war, but it had been over for a long time by the time I was born in 1903. About all I know is that he was at the battles of Marietta and Atlanta. He said they burned Atlanta all up.

Jack Dowdy

My great-great uncle, Jacob E. Dowdy, was a sergeant in the Confederate States Marines during the Civil War. He was stationed aboard the ironclad CSS *Savannah*, which guarded the harbors of Savannah and Charleston. Uncle Jake was wounded and received a medical discharge late in 1863, two years before the war ended. He must have been hurt pretty bad to have been discharged because the Confederacy was so short of manpower. He came back to Lumpkin County and farmed. Despite his war injury, he lived to the ripe old age of eighty.

Ed Ridley

When the Civil War broke out, great-grandpa Alex Ridley and his oldest son Math walked to Tennessee to join the Northern Army because the Georgia Home Guard was going to kill them if they didn't join the Confederacy. My great-grandmother didn't know where they were, but the Home Guards thought she did, so they made her walk barefooted all the way to Cleveland, Georgia. There they put a rope around her neck and hung her from a big ol' oak tree until her big toes just barely touched the ground. When they couldn't get anything out of her, they finally turned her loose, and she walked home, but she lost her hearing from that experience.

Lula Fields Burns

Grandma Nancy [Nancy Jane Cain Porter] was a girl during the Civil War, and she used to tell me how she and her brother would take their cattle off in the woods to hide them whenever word got around that the Home Guard was in the area.

They Wore Both Blue and Gray

Barbara McDonald

My great-great-grandfather, John R. Lance, was struck by lightning and killed in 1851. His wife Sarah died three years later, leaving three small boys: Dallas, Polk and Bill. Sarah's spinster sister, Laurin Satterfield, was appointed their guardian and raised her nephews.

The boys grew rapidly and were so large for their age that some Home Guards came to their house and threatened to hang them if they didn't join the Confederate army. The soldiers threw a rope over a limb and were getting ready to hang the first boy when Aunt Laurin grabbed a hot fire poker from under the wash pot where she was washing clothes and ran the guards off. The Home Guards never bothered them again!

Claude Collins

My grandpa Joseph McDougald was a staunch Baptist who didn't want to enlist when the Civil War broke out because it was against his religion to fight. For a time he hid out in the woods and slept in a hollow log but finally went to war as a Confederate soldier. He later changed sides and fought for the Union because he said that if he had to serve, he wanted to fight for the right side. His wife Nicy had a hard time feeding her family while Joseph was off in the war. She gathered many wild plants for food, including maypops, which she fried like okra. She also picked blackberry leaves and cooked them like turnip greens. Salt was unavailable, so she dug up dirt from the smokehouse where they had salted meat in the past.

Rachel Patrick Graves

The Civil War brought many hardships and sorrows to my great-great-grandmother, Rachel Sparkes Vaughn, and her family. Her father, Malone Sparkes, was too old and infirm for military service, but her brothers, William and Wimpey, went off to fight for the Confederacy. Wimpey was killed in Virginia on August 23, 1862, at the age of seventeen.

One winter night, a band of bushwhackers made a raid on the Sparkes's somewhat isolated home. These rough mountain men tried to evade military conscription by hiding out, and they lived by preying on helpless women and children whose menfolk were off fighting.

Malone's wife Irene was afraid for her husband, for bushwhackers had been known to beat or hang old men found at home. She had one of their daughters get him to sit in the corner and read the Bible while she greeted the raiders cordially and invited them in. She called them "gentlemen" and offered to give them whatever she had. While she was cooking supper for them, they stomped through the house, taking most

of the family's blankets, but they ignored Malone sitting quietly in the corner reading the Bible.

The youngest boy, Joe, was sent out to take care of the bushwhackers' horses while they ate and drank all the buttermilk left from Irene's churning. The outlaw band finally departed, taking most of the family's meager supply of food, but no one was harmed.

Rachel was not at home when this happened because she had her own home by this time. Her husband George joined the Confederate Army and was captured at the Battle of Gettysburg. He apparently died while a prisoner of war, but no official report of his death was ever sent to his wife.

The last letter he wrote to her was dated August 26, 1862. Enclosed was a ribbon for baby Mollie's hair.

He may have had a premonition of his own death, for he told Rachel that he wanted his funeral preached on Revelation 14:13 if he never came home. He also told her to sell his cabinet-making tools. How her heart must have ached when she read, "I want to see you the worst I ever did. I see no satisfaction here. If I cood be at home now to talk and sing and pray, I wood be sadisfid. I lov you above all things."

Rachel never remarried, always hoping that George would return, and for the rest of her life, she could never talk about him without weeping. Still hoping he would return home from the war, she wove him a shirt that is still in our family's possession. The cloth is woven with areas of double-thickness on the shoulders and at the elbows. The front is pleated, and the buttons are mother-of-pearl. No collar was ever attached to the shirt, for Rachel thought her husband's neck size might change during the hard life of a soldier.

5.
Living on the Land

In the nineteenth and twentieth centuries most of the population of Lumpkin County lived on farms in the rural countryside and survived on what they could take from the land. A large family meant more hands to work in the fields, and even the youngest children knew they were important to the family's survival.

The land provided bountifully for many years. Trees were readily available to build log houses, and American chestnut trees were especially prized, not only for their durable wood but also for their nuts, nourishing fare for humans and animals alike. The woods also provided wild game, which men and boys hunted to supplement the meat supplied by farm animals.

The fertile soil produced crops that were harvested and preserved to last through the winter months by drying, pickling, storing in root cellars and eventually by canning. Families who grew more than needed for their personal use loaded their surplus into wagons to sell in Dahlonega or Gainesville. They used the cash gained in this manner to purchase items they couldn't grow, such as coffee, salt, shoes, needles and the like.

In time the land became "farmed out" from overuse. Seeds had to be planted far apart because there were so few nutrients left in the soil. Many people would have gone hungry if Glad Owens had not come to Lumpkin County in 1929 to serve as the area's first county agent. He taught farmers to restore and maintain the soil's nutrients by such practices as planting cover crops, crop rotation and use of fertilizer.

The Best of "I Remember Dahlonega"

Memories of Life on the Farm

Jack Dowdy

Folks used to live on what they could raise: mostly pork, corn, milk and syrup. Vegetables had to be pickled or dried. I remember helping cut cane, stripping off the leaves and headers for fodder to feed our livestock, and then taking the stalks to the syrup mill on Oak Grove Road. A mule pulled the grinder that squeezed the juice out of the stalks. The juice flowed down a trough to the boiler where it was cooked down to syrup and put in fifty-five-gallon barrels.

Captain Walker

I remember when kudzu was brought in around 1940. It was supposed to be real good to cover up bare red banks and prevent soil erosion. I put out 250 slips, but it was awful dry that summer, and only three lived, which I regretted at the time. They didn't grow for several years, but then they took off and haven't stopped since. I'm still trying to get rid of them! I've cut vines as big as my leg. I remember someone asking a government man at a farmers' meeting how to get rid of kudzu. His answer was, "Run like hell!"

In the old days if you got out of something to eat, there was no welfare office to go to for help. You had to get out and hunt something yourself. Life was hard back then, but it seems to me that people's morals were better. There wasn't so much trouble in the settlement, and a person's word was good enough. Nowadays you've got to sign on the dotted line and get all your neighbors to sign, too!

Elmer Garrett

You went barefoot in those days, and the hide on the bottom of your feet would be as thick as your finger, so that you could walk over burs and never feel a thing. Lots of time all we had to eat was what I could hunt, and I laid out many a night in the rain, sleet and snow during the '30s in the hopes of shooting a squirrel or rabbit or possum or coon.

Violet Smith Berry

Everybody went barefoot back then, sometimes even to church. We could only afford one pair of shoes in the winter and another pair for church, and they usually got too small before it was time for new ones. I can remember

having a pair that was so tight that I toted them until we got almost to church and then put them on just before we got to the door. When our shoes got thin on bottom, Daddy put new soles on them. When the leather started to tear, he sewed them up with beeswax thread.

Leamon Walden

I remember picking up chestnuts in Chestnut Cove before all the American chestnut trees died in the 1920s. There were trees in there two and three feet thick. Another area where we carried our buckets and sacks was called "the stomp ground" because it was a flat area on top of a ridge where cattle grazed. In those days people still let their cattle run loose in the mountains, but you had to bring them out in the fall when the acorns started to fall. If you didn't, the cows would eat them and die. People cut marks on their cows' ears so they could recognize which ones were theirs.

We carried chestnuts to Gainesville with mules and wagons and sold them on the square along with apples, pears, potatoes and cabbage that we had grown. One time when Grandpa Bill Gooch was in Gainesville peddling his produce, a man complained, "These here chestnuts have got worms!" Grandpa looked him square in the face and said, "The man that buys land buys stones, the man that buys beef buys bones, and the man who buys chestnuts buys worms."

Mary Poore

When I was growing up, people used to drive their sheep from the mountains to market in Gainesville, and they used to camp just across the road from our log cabin on what's now Highway 60. Daddy let them drive their sheep in a fence lot so they wouldn't wander off in the night. They traveled in covered wagons and cooked on campfires. They also carried chestnuts to sell in Gainesville so they could buy things like coffee and lard and shoes. That was before the blight killed off all the chestnut trees.

Eulene Poore

My mother [Myrtle Ledford Sullens] was a talented seamstress who could look at a picture, cut out a pattern from old newspapers, and sew a dress that was identical to the picture. Men welcomed the advent of the poultry industry in this area for the income it provided, but women had an additional reason: poultry feed came in colorful printed bags which could be used to make everything from dresses and pajamas to quilts.

The Best of "I Remember Dahlonega"

When the truck arrived with feed for our chickens, Mama and I always looked for the prettiest floral prints and asked for four bags alike so we would have enough material to make a dress.

J.B. Jones

Until the poultry business was introduced during the 1950s, Lumpkin County had pretty much stood still since the Civil War. It used to be that everybody had a cow and a hog and yard chickens that might weigh three pounds apiece. Now one person can raise one hundred thousand chicks that grow to four pounds in six weeks. When Glad Owens came here as the first county agent, he taught local farmers how to take care of the land and get more out of it by adding nutrients to the soil. Before that, the land had been farmed out. Glad taught farmers how to increase their production from ten to fifteen bushels of corn per acre to one hundred bushels per acre.

Nell Todd Brown

We were the first in the area to have a chicken house. Local folks thought this was strange because everybody knew that chickens were meant to run loose and roost in trees. They insisted it wasn't "natural" to coop them up in houses. When they discovered that we continued to get eggs all winter when their chickens quit laying due to the cold, it wasn't long before more chicken houses were being built!

Herman Caldwell

We had boo-koodles of flies back then. Whenever they got too bad, my mother [Cardelia Walker Caldwell] would send me out to pick her some "twelve o'clock flowers," which grew wild in the valley. She would beat them up, pour sweet milk over them, and set the pan out on the table. When the flies started sucking up the milk, they fell over dead in a few minutes.

Virginia Abercrombie

Houses are a lot tighter now than they used to be. When I was growing up, you could look through cracks in the floorboards and watch the chickens scratching in the dirt! We scrubbed the floors with homemade corn shuck mops, and the extra water went right on down through the cracks. We wore three or four layers of clothes to stay warm in the wintertime, and we heated irons in the fire to warm our beds at night.

Living on the Land

Marcella Crane Gibson

After my husband and I married, the first place we lived was a little log house with cracks in it so big that we had to pull the covers over our head to keep off the snow the wind blew in!

Berbie Robinson Harkins

Daddy grew lots of cotton before the boll weevil came in. Mama always used the cotton from the late-opening bolls to make quilts. She also carded and spun it into yarn, which she knitted into gloves and socks for us. She would poke our shoes full of cotton bolls every evening, and we had to pick out all the seeds before we could go to bed.

Life was hard in the old days, but I wouldn't mind living them over again. Even though there was always plenty to do, we had time to visit friends and neighbors back then, and folks seemed to be more caring. If you got sick, somebody came and stayed with you until you got well. Today's younger generation wouldn't know how to start if they had to survive off the land. Lots of children nowadays don't live near their grandparents and hardly know them. I wouldn't take anything for what I learned from my grandmothers—what one didn't teach me, the other one did.

6.
Always Plenty to Do

Boredom was never a problem for people living on a farm. Food had to be prepared "from scratch," which meant killing and plucking the chicken before putting it on to cook. Women sewed their families' clothes, and they knit their socks and sweaters—after shearing the sheep, washing, carding and dyeing the wool before spinning it into thread! Once a week they washed clothes with homemade lye soap, usually keeping the oldest child home from school to draw water from the well to fill the pots. The clothes had to be wrung out by hand and spread out to dry on tree limbs or bushes. The next day was spent ironing all the garments with heavy irons heated on the stove or in the fireplace.

Men cleared the land of trees and stumps, plowed the fields, sowed the seed, hoed the weeds, harvested the crops and tended the livestock. Many of them also ran syrup and grist mills and did carpentry, blacksmith work and sawmilling on the side. When road construction or other jobs were available, men sometimes walked miles to the location, worked hard all day, and then returned home on foot well after dark.

Children were responsible for chores like bringing in firewood, gathering eggs, looking after younger siblings, milking the cows and helping out with all the adult tasks as soon as they became old enough.

On Sunday people rested, meaning that they went to church and visited with friends—after they had milked the cows and fed all the livestock.

Always Plenty to Do

Maggie Waters Wehunt Remembers Making "Leather Britches"

There was always plenty to do out in the country. We worked out in the fields in the summertime and made good crops. We did a lot of canning, and Mama learned to can the first vegetable soup made in the settlement.

One vegetable we kept on drying was string beans, and I still make what folks used to call "leather britches." I break my beans and dry them out in the sun two or three days, but in the old days folks used to tie them on long strings and hang them by the fireplace. To cook leather britches, I rinse the dried beans, parboil them, rinse them again and then put them back on the stove and boil them with a piece of fat meat until they are tender. I like them better than fresh beans.

We raised all our meat and always had plenty to live on. Besides the cows and hogs, we kept sheep, chickens, ducks and guineas. After the sheep were clipped, Mama would wash the wool until it was snowy white. When it dried, she carded it and spun it into thread on her spinning wheel. In the winter my sisters and I would sit around the fire and crochet sweaters and hats or piece quilts.

Sometimes a family would have a "workin'" and invite their friends and neighbors to come help them. The women would cook up a big meal while the men were cutting firewood or raising a barn or whatever else needed doing. We got our work done and had fun doing it. I mean to say we had a good life back then—a lot better than nowadays to my way of thinking. Today nobody has time to visit any more.

We washed clothes in a big ol' iron pot below the house with homemade soap. We lifted them out of the boiling water with long sticks and rinsed them in tubs fed by water piped from the spring. When we got ready for a bath, we carried water from the springhouse, heated it on the stove and carried it upstairs where we sponged ourselves off good. We were always as clean as a pin even if we didn't have big bathtubs and showers.

About once a year we carried our wooden straight chairs down to the wash place and scrubbed them with white sand to get them pretty and clean. Every weekend we threw water on the wood floors and scrubbed them good with a homemade shuck mop. We swept the water out the door.

It's true that we didn't have the modern conveniences we have today, but we didn't know any better, so we never missed them! I've worked hard all my life, but I never minded what I had to do. I'm eighty-four now, and I still love to work. Right now I can hardly wait for the weather to hurry up and get pretty so I can get started gardening!

The Best of "I Remember Dahlonega"

Sam and Lois Saine Remember When Nobody Locked Their Doors

Sam: I'll be ninety years old in May if I live that long, and life is a whole lot different now from what it used to be. I remember walking ten miles to town, working eight hours with a pick and shovel, and then walking ten miles home again. I helped build Highway 52, which was the old road to Gainesville. We didn't have any TVs or radios, so after we ate supper, we went to bed.

The old days were hard, but they were good. I think everybody was healthier and happier back then. If you did get sick, all your neighbors would come in and work your crops until you got back on your feet. If you were still sick when it came time for harvest, they would come gather them for you. Neighbors helped each other out and had a good time doing it. Lots of hands made the corn shuckin' go a lot faster. Everybody wanted to hurry and get to the half-gallon jug of double and twisted whisky at the bottom of the crib!

People worked hard, but they still found time to visit and go to church. You could go off for a week at a time without locking your door, and when you came back, nothing would be gone.

My daddy, Will Saine, built a log house under a bluff at the foot of Cooper Gap Mountain. Houses didn't have glass windows like they do today. They had wooden shutters, and it was real dark inside when they were shut. When you needed lumber to build a house or barn, you "deadened" the timber by cutting all the way around a tree to make it die. You didn't cut it down yet but left it standing to dry so the boards wouldn't shrink later.

I remember cutting chestnut trees to make split rail fences. Back then all the livestock ran loose. Instead of fencing them in, you fenced in your house and the area you farmed. The square in Dahlonega used to be a big mud hole with cows and hogs running loose everywhere. A lot of people didn't like it when they passed the stock law requiring everybody to keep their animals penned up, but it was the best law ever passed!

Lois: There was no electricity in those days, so we carried oil lamps from room to room and cooked in the fireplace. Pots and pans hung from a wire over the fire, and corn bread and biscuits and even cakes baked in a Dutch oven set right in the hot coals. You used a pair of long tongs with a hook on the end to take the lid off to see if the bread was getting brown.

When it got done, it was so good that it would melt in your mouth! Things cooked in aluminum and glass just don't taste as good as they used to when they were cooked in an iron skillet or Dutch oven.

In the wintertime you had to keep turning around and around in front of the fireplace to get warm before running and jumping into bed. You had a hot iron under the covers to keep your feet warm. After the shingles on the roof dried out and shrunk, fine snow would sift through, so you might wake up in the morning to find your bed covered with snow!

Did you ever sleep on a straw tick? You talk about a good bed! The first night you sleep on one, it's so high it seems like you need a ladder to get up on it. After about a year, the straw gets so packed down that you have to empty the tick and wash it and stuff it with new straw. Some people who didn't have straw used corn shucks. Pillows were made from chicken and duck feathers.

Sam: I was plowing a steer when I could just barely reach the handle. Another one of my jobs was toting water from the spring where Mama kept her milk. When I was about eighteen, I went to work hewing crossties for the railroad. First we cut white oaks with a crosscut saw. Then we hewed them flat with an ax. They had to be first class or they would be culled. Let me tell you that was hard work! You couldn't do more than two or three a day, and you only got paid twenty-five cents per crosstie. The ties were hauled to town on a wagon, and from there they were sent wherever they were needed.

Lois: It took all day to do a washing, and it was hard work. First you had to tote your clothes down to the spring. Then you spread them out on something that looked like a meat cutting board and beat them with a wooden paddle called a battling board. Finally, you boiled them in a big iron pot with soap made of lye and tallow that would eat your hands up. It took all day and ruined your hands, but you talk about clean clothes!

Nettie Collins Remembers Getting Married at Fifteen

I was born way back across the Etowah River up in Hightower District, and I attended the old log Etowah School. My daddy, "Little Johnny" Rider, was Lumpkin County tax commissioner for a number of years. He used to walk twelve miles each way to the courthouse until he moved us into town.

I was going to school in town when I met a redheaded boy named Johnny Collins. Pretty soon we were real sweet on one another, and one

day he said, "Let's you and me go get married." Ol' Man Townsend [editor of the *Dahlonega Nugget*] was justice of the peace, and he married us on May 20, 1923. I was only fifteen at the time, but Johnny and I stayed married for seventy years. We had a good life together until he died in 1992. He was the greatest man in the world and was real good to help me with whatever needed doing.

Before the children started coming, I used to ride with Johnny to haul cabbages and apples and other produce to Gainesville to sell at the wagon yard. We camped out two nights, sleeping under the bow-framed covered wagon.

I had every one of my ten children at home. Sometimes "Doc" West or "Doc" Cantrell came, but other times I just had a "Granny Woman." The older children looked after the younger ones and helped with the cooking.

We never had much in the way of material things, but there was always food on the table. We kept chickens and a cow and grew lots of vegetables in the garden. I did my canning in a big washtub set over an open fire in the backyard. We made barrels of pickled beans and kraut, and we were always careful to do it when the signs were right.

We smoked fruit to preserve it. After quartering it up, I put it in a flour sack hung over the side of a big barrel with a red hot rock or plow in the bottom. After throwing in a teaspoon or so of sulfur, I spread a doubled-up quilt over the top of the barrel to hold in the smoke. The fruit came out bleached as white as could be, and it tasted so good.

In later years after we moved to the Cane Creek valley, Johnny bought a tractor to do his plowing, but he always loved his mules and drove them on Gold Rush Festival weekends. He provided one of the teams for the wagon train that carried Dahlonega gold to Atlanta in 1958 to put on the dome of the capitol.

Curly Pruitt Remembers Drawing Water from the Well

My parents named me Leroy, but my algebra teacher took one look at my wavy blond hair and said, "I'm going to call you Curly." The name stuck, and most people don't even know my real name.

After I finished seventh grade at Cavender Creek School, I started catching the bus to town for high school. Just before I left for school, I always slicked my hair down with water, and on cold winter days, it would freeze as hard as a rock before I got on the bus.

I can remember nights so cold that a bucket of water sitting at the foot of the stairs inside our house would be frozen solid by morning and would

Always Plenty to Do

Middy blouses were popular when Nettie Rider (left) was photographed with her first cousin Lela Rider ca.1920. *Courtesy of Ann Collins Lawson.*

have to be put on the stove to thaw. We slept under piles and piles of quilts to stay warm. When there was ice and snow, Daddy shoveled us a path down to the barn before dawn because we had to milk the cows and feed the mules before breakfast. We got up at four o'clock every morning.

Monday was washday, and being the oldest of the ten children, I had to stay home from school to help Mama. After building a fire under the wash pot, I drew buckets of water from our eighty-seven-foot well until my arms ached. I also helped beat the clothes with a battling stick and scrubbed them on a rub board. I drew water daily for household drinking and washing, but on Saturdays when the weather was warm enough, we took a bar of soap (Ivory, because it floats) and went down to the branch to get an allover bath.

Mama [Mary Girlie Gillespie Pruitt] made most of our clothes on her old treadle sewing machine, using feed sacks for material. We wore designer shirts and dresses, though we didn't know it at the time. She colored the pockets and collars with Ritz dye to make them contrast to the rest of the garment. About the only thing she didn't make were our overalls and shoes, which we ordered once a year from Sears & Roebuck. When the bottoms of our shoes wore out, Daddy bought new soles and put them on the shoes himself.

The Best of "I Remember Dahlonega"

Our favorite family thing to do was to sit around on Saturday night listening to the Grand Ol' Opry on our Sears & Roebuck radio. When the battery started getting weak, everybody kept moving closer and closer to hear what was going on!

I signed up to join the Air Force in 1952. That's when I got my first barbershop haircut. My mother had always cut my hair at home when I was growing up. Just before I left, Daddy [James Russell "Jim" Pruitt] gave me some good advice that has stayed with me all my life. He said, "Son, don't ever tell nobody a lie, give a man eight hours of good work, and always help people because you'll always get it back."

Dahlonega was still a sleepy little town when I left here in 1952. After I'd been living in Texas for a while and returned home for a visit, I made the mistake of saying, "Dad, do you know that you're at least twenty years behind here in Dahlonega?" I'll never forget his response. He just looked at me for a minute and then drawled, "Well, Son, we ain't in no hurry to catch up."

Life was hard back in the '30s and '40s, but there was lots of love in our family and community, and that held life together. People helped each other out a lot. If somebody needed a barn, folks gathered for a barn raising. If somebody's cow died, they took up money to buy a new one. When Dad got sick, the neighbors came to cut wood. We didn't even have locks on our doors, and we never lost anything.

Viola Berry Fields Remembers Clearing New Ground to Farm

I grew up at the foot of Nimblewill Mountain about five miles beyond Nimblewill Baptist Church. This was before stock law came in, and our hogs ran loose in the mountains like everybody else's. They knew Daddy's voice and would come when he went to their feeding ground and called them to come eat.

We didn't have any money for fertilizer, so Daddy [Willie Berry] spent the winters clearing off new ground that hadn't been farmed out and was still fertile. One of my jobs was pulling the sprouts off the stumps of trees he cut down so they wouldn't grow back. My brothers and I also helped pile the brush and burn it. Another reason Daddy wanted to clear new ground was because renters got to keep everything they made off of it for the first two years. After that you had to pay the landlord a third or fourth of everything you made.

Always Plenty to Do

Curly Pruitt got his first barbershop haircut when he joined the Air Force in 1952. *Courtesy of the author.*

I was the oldest girl of nine children, and I can remember having to stand on a chair to cook and wash dishes every time Mama [Hannah Grizzle Berry] was in bed having another young-un, which she did every year. I dreaded to see the "Granny Woman" [midwife] coming so bad that one time I hid out in the corncrib. They never did find me until I got hungry and came out.

Our day started early, and I can still hear Daddy saying, "Daughter, get up; we've got to go to the fields." I worked alongside him and my brothers until eleven o'clock, when it was time for me to go home and start cooking the noonday meal. Everybody had to work hard just to survive back then, but young people nowadays can't imagine what it was like. When I tell my grandchildren some of the things we did, they think I'm just telling them fairy tales!

I loved to walk behind my daddy when he went down to the store run by Woodrow Parks's father not far from Nimblewill Church. We didn't have any money, so we saved our eggs (what the possums and other varmints didn't get) to barter for sugar and coffee. We hardly ever got to eat eggs ourselves except for special occasions. They were almost as

much of a treat as the honey we got occasionally when Daddy would find a bee tree and rob it.

We worked hard back then, and we didn't have much in the way of material goods, but it seems to me that people were happier. There wasn't as much pressure as there is now, and people weren't always rushing around like they were going to a fire. We had a lot of fun doing things together like popping corn and roasting chestnuts, making quilts and shucking the corn. Everybody was like one big happy family, and we had time to visit with each other and help each other out.

Fannie Lou Bryan Remembers Boiling Eggs and Baking Corn Bread

My daddy, Frank Homer Wimpy, was born in 1889. He served in the Marines 1911–1915 and was aboard ship during the Mexican War. He was raised near Cane Creek Falls, and I remember hearing him tell how his daddy taught him and his two brothers to swim by holding onto their horse's tail in the pool below the falls. He wouldn't allow my sister or me to go swimming, however, because he was afraid we'd drown!

After Daddy got out of the Marines, he married my mother [Fannie Walden] in 1915, and they farmed for a number of years. I remember helping hoe the vegetables and pick cotton and how sore my hands got from those pointy, sticky burs!

My mother died when I was ten, so I took over the job of cooking, not only for the family but also for Daddy's hunting dogs. There was no such thing as commercial dog food in the 1930s, so I had to bake two big pans of corn bread every day to feed four or five Walker hounds and two bird dogs. The only difference between the corn bread they ate and the corn bread we ate was that I didn't sift the meal for the dogs.

Daddy loved to go fox hunting, and sometimes he'd take me with him. The best time to go was after a rain because the dogs could pick up the fox's scent better when the bushes were damp. Sometimes he and Gordon Burns and Rufe Ed Baker would stay out hunting all night with their kerosene lanterns and flashlights.

There used to be lots of mad dogs back in the days before rabies shots, and one time a rabid dog came through and bit some of Daddy's hunting dogs. He had to destroy all of them, and it like to have broken his heart. He got more dogs after that but never the full pack he used to have.

Always Plenty to Do

Back when I was growing up, there wasn't any such thing as all the candy Easter eggs you see in the stores nowadays. All we had were real eggs, and we only got them on special occasions. Like most people who lived out in the country, we kept chickens but saved the eggs to take into town to trade for things we couldn't grow, like coffee, sugar and matches.

Easter was a special occasion, so we children always got to have a few extra eggs to hard boil and hide for one another to hunt for. We wrapped them in crepe paper before putting them in the boiling water, hoping the dye in the paper would tinge them a light pastel color. If we didn't have crepe paper, we used them just the way the chickens laid them. After we played with the eggs all day, we looked forward to eating them. Eggs were even more of a treat for us than candy is for children now.

My grandfather died when Daddy was only five years old, and his mother had to save every egg their chickens laid to have money to pay her taxes. One year Daddy started putting aside one egg a day to save for Easter. He could hardly wait to boil those eggs and hide and eat them. On Easter morning he rushed out to the barn to get his eggs only to discover that an ol' hen had been setting on them. By that time the baby chicks had already started to form, so Daddy didn't have any Easter eggs that year. About three weeks later that ol' hen was proudly strutting around the barnyard followed by a bunch of baby chicks!

I married Sheals Bryan in 1940, and we moved to Baltimore when my husband and my daddy went to work in the defense plant there during World War II. I was glad to move back to Dahlonega when the war was over.

Before the streets in Dahlonega were paved, I used to have to wade through ankle-deep mud to get to work, carrying my white work shoes to change into after I reached dry ground. Sometimes it would start raining after I went to work; then I had to wear my white shoes home through the mud. What a mess! I sure was glad when the streets got paved.

Vernon Glaze Remembers Meeting His Wife at a Cotton Pickin'

I met my wife Leola at a cotton pickin'. Although the main purpose of a cotton pickin' was to harvest the crop, it wasn't all work and no play. I remember making popcorn balls with sorghum syrup and rubbing butter on our hands so they wouldn't get sticky. We played some kind of game

where we drew names and got to walk around the house with the person whose name we drew. Leola Ash drew my name, and that's how we got introduced to each other.

Big crowds of people used to come to church during revivals. I've seen three preachers preaching at the same time: one in the church, one at the spring across the road and one in the "hitching ground" where the horses and mules were tied up. People would sit in the windows of the church, and babies on quilts would be lying all over the place. One family had so many kids that they got all the way home from a revival before they realized they'd left one of the children asleep at the church!

When somebody died, the church bell was rung to let people know to go comfort the family and dig the grave. You could hear the bell all over the hills and through the hollows for miles around. On the day of the funeral it tolled to let people know the hour of the service. If it was at eleven o'clock, it tolled eleven times.

Wahoo Church used to baptize in the pond at Barnes Mill. I remember that mill well because it was still in operation in the 1950s. Olin Barnes was the miller, and he could grind corn and gin cotton at the same time. He also ran a flourmill upstairs. The mill finally shut down because most folks had taken to buying store-bought meal instead of growing their own corn.

My brothers Roy and Robert and I didn't know what a school bus was, so we walked to Wahoo School, carrying our lunches in lard or syrup buckets. What we usually had to eat was biscuits with syrup and butter, some leftover meat and a sweet potato. We toted our drinking water from the spring across the road. At recess we played games like hide-and-seek, fox-and-hounds and throw-the-ball-over-the-schoolhouse. If we didn't have a real ball, we made one out of thread by raveling out old knit socks.

We raised almost everything we ate, and we took eggs to the store to exchange for things we couldn't grow, like coffee and sugar. We always had plenty of meat, especially ham, and what they call "country hams" nowadays don't taste nothing like the ones I grew up on. Sometimes we smoked our hams, but they would keep for a year just being salted and kept in a cool place. Back then most people had underground storm pits or root cellars.

We kept milk cool by setting it in a washtub filled with water or putting it in a bucket and lowering it down into the well. When we were working in the fields, we carried our milk with us and put it in one of the numerous nearby springs so it would stay cool until we got thirsty. We didn't even own a refrigerator until the 1950s even though

we got electricity about 1948. The first electrical appliance we bought was an electric churn so we didn't have to keep wearing out our arms churning butter.

I have lots of memories about the "good old days" when we were young. I remember how long and hard we worked. We didn't have anything like a mowing machine or hay bailer, so we cut the hay by hand and tossed it up on the wagon with pitchforks. I remember loading fodder on the wagon by moonlight and throwing it up in the barn loft by the light of a lantern long after the sun had set.

Still, them days were good days because people cared about each other and were real good to help each other out. Nowadays many people don't even known their neighbors, but back then you knew everybody, and everybody knew you. When my dad died in July of 1946, folks came in right after the funeral and had his fields cleared in a short time even though they had to leave their own work to come help us out. Yep, those were good days, but I sure am glad we don't have to work that hard any more!

Duffie Grizzle Remembers When Shoes Were the Same for Both Feet

I was born December 26, 1894, and I've seen lots of changes take place in Lumpkin County and the world in the past century. I remember when a man worked from daylight to dark for eighty cents a day. In those days when you got a pair of shoes, you had to make them last a long time. Brogans looked the same for both feet, and on a cold morning you had to warm them up in front of the fire to get them on!

There weren't many bridges over the creeks, so if it rained hard while you were off visiting your neighbor, you might have to stay several days waiting for the creek to go back down. One time a family was finally leaving after a week's stay during one such flood. When they noticed their hosts were crying, they said, "Don't cry; we'll be back soon."

"Oh, we ain't crying 'cause you're leaving," the tearful hosts replied. "We're crying 'cause you-uns done et up everything in the house!"

My daddy tended John Anderson's grist mill on Yahoola Creek, and he was a good miller. Sometimes he'd let me tend the mill when he had to go to town. I remember the mill's overshot wheel and buckets and the bell he rang three or four days a week to let people know it was mill day. You could hear that bell for miles around.

The Best of "I Remember Dahlonega"

Daddy was a pretty good fiddler, too. I remember lots of square dances and banjo pickin's. When Charlie Ridley brought out his banjo, his brother Frank and Dolphus Grizzle would hit the floor, and you talk about dancing!

Besides dancing we used to have candy drawings and play "My bird's a pretty bird; what kind's yours?" If somebody guessed the kind of bird you were thinking of, you got to hit them in the face with a wet rag!

It used to be an all day wagon trip to Gainesville. After I got to the wagon yard and got my mules fed and watered at Bagwell's Barn, I would fry some sausage and cabbage over the fireplace in the camp house. After supper I'd sit around and talk with other folks who'd come from surrounding counties. The next day I peddled my cabbages, potatoes and green beans on the square or out around the mills in New Holland. Sometimes I sold as many as thirty-six dozen eggs on one trip. Then I would stock up on rations like lard and flour and head for home. Later on, after I got a Model-T truck, I hauled two or three loads of produce to Atlanta every week.

I raised cotton when I was a young man. At one time it was about the only thing you could make any money on. I remember taking it down to have it ginned and one time having a 610-pound bale. When I sold it and got out of debt, I used some of the money to buy me a bicycle, but I sold it pretty quick. I discovered I didn't have no need for a bicycle in these mountains!

I remember when the boll weevil and the bean beetle first came in. You didn't used to have to poison your cotton and beans and apples and peaches because there wasn't anything to bother your stuff.

I remember the first car I ever saw. I heard something crackin' and poppin', so I ran out to see if the house was on fire! Wally, Red and Cap Walker were headed to town in their wagon, and when that "log engine" passed them, it like to have scared them and their steer to death.

After World War I broke out, I was ready to go when they called me. I was sent to Camp Sheridan in Montgomery, Alabama. I never did go overseas, but we had done been notified that we were fixin' to go real soon. It took a while to get dressed in our uniforms because we had to lace up the leggin's. I worked in an office, but I never could do much with a typewriter. I delivered mail, too, and men were all the time asking me, "What do you hear, Grizzle?" They were all wanting the war to be over so they could go home.

After the war I married Elsie Lingerfelt, and we raised ten children. She was a good woman. She was only fourteen and real slim and

Always Plenty to Do

Private First Class Duffie Grizzle (left) in his World War I uniform. *Courtesy of Jimmy Anderson.*

pretty the first time I ever saw her, and I remember wanting to find out more about that girl. Finally, I walked her home one day and got invited to supper. We went together three or four years before we got married, and she wrote to me nearly every day when I was in the army. When I went to get her to be married, her brother Willy like to have had a fit because I took her away during cotton chopping time!

I've got through life pretty good, and I'm glad I've lived as long as I have. I still do a right smart bit of work, and I ain't in no hurry to leave. Of the folks I grew up with, most of those who aren't gone are in a nursing home. I'm still able to drive my car up to Copperhill [Tennessee] to visit some of my family living there, and I'm proud of it.

My mama and daddy always taught me to be honest and do the right thing, and that's the best advice I know how to give. I always tried to treat the other fellow the way I wanted him to treat me and to give good measure. One of the things I learned when I was on jury duty was that everybody don't see alike. There's lots of differences in the way people look at things, some seeing one way, some another.

The Best of "I Remember Dahlonega"

There are periods of time when all goes along pretty smooth, but life isn't all roses. Everybody has times of disappointments and sickness. It seems like from fifty-five to sixty-five is an especially trying time of life and takes a lot out of you, but if you make it to sixty-five, you may live to be an old man like me!

7.
Getting from Here to There Back Then

Early roads coming into Dahlonega were steep, curvaceous and frequently impassable when it rained. Visitors and newcomers arrived thinking they had reached the end of the earth. Horses navigated the deep ruts and mud puddles with relative ease, but cars frequently got stuck and had to be pulled by teams of horses. It was common practice to tie a tree to the car's rear bumper to provide extra braking when driving down steep hills. Creeks and branches had to be forded until relatively modern times. When they became swollen with the runoff from heavy rains, there was no way to cross them until the waters subsided.

Memories of Early Roads and Vehicles

Oscar Cannon

Back around 1918, I had a team of mules named "Jack" and "Billygoat," and I did a lot of hauling for other folks who didn't have a team. Mules are steadier than horses and don't give out as quick. When Ol' Man John Satterfield took a picture of me with my mules and wagon, he put a big old black thing over his head and liked to have scared my mules to death!

Callie Ridley

When we wanted to go somewhere, we had to walk unless we rode in the wagon. We used to have a young steer that was bad to stop and lie down when we hitched him to the wagon. One time he lay down right in

Oscar Cannon with his mules, Jack and Billygoat, in 1918. *Courtesy of the author.*

the middle of the road. My brother Carl and I had to drag him out of the way so a truck could get by.

Wesley Dockery

Dockery Lake was named for my grandpap, Andrew John Dockery. He homesteaded in that area in the 1850s and built a log house out of chestnut trees. He also ran a gristmill with an overshot wheel on the creek.

Grandpap was a hardworking man, but he didn't believe in working any harder than he had to. When he wanted to build a new road from his house to the top of the mountain at Dockery Gap, he took a crowbar and punched holes where he wanted the road to go. After filling the holes with corn, he brought in some long-nosed mountain rooters [wild hogs], who did just what he had in mind for them to do: They dug up the ground rooting for the corn! After they got the soil broken up good, he took his horses and scraped it level to finish making his road.

Getting from Here to There, Back Then

Harold West

I remember when gasoline and kerosene were hauled into Dahlonega in big tanks on a wagon pulled by two black mules. Will Jones's store was the only place in town to buy gas, and only a few people had cars. My daddy, Dr. S. A. West, had an old black Model-T Ford (black was the only color cars came in back then), and he used it to visit his patients in several counties.

I frequently went with Daddy to assist him when he was making rounds. In those days there was no age limit on driving, and you didn't even have to have a license. If you could afford a car, you could drive it! I started learning to drive in 1912 when I was six years old, and by the time I was eight, I was earning seventy-five cents a day driving the car for our mailman during the summer.

Herbert Gooch

I remember the first car I ever saw. I was scared to death it was going to run over my dog. Later I got myself a 1924 Model-T, and it was the prettiest thing I ever saw. It could move on out at twenty-five miles an hour.

Cars in those days were all the time having flat tires. It took me all night coming home from Gainesville once because I had to stop I don't know how many times to take a tire off and patch it with rubber and cement. It wasn't too cold inside in the winter with the curtains pulled, since T-Models boiled like a pot on the stove. They didn't have any brakes, so you had to use the gears to stop. Roads were so bad back then that you'd get stuck about every time you'd start to town. Then somebody would have to get out and push!

Captain Walker

I bought my first truck in 1927, and the brake linings were forever rusting out from getting wet when I forded the creek. There were no bridges over the Yahoola back then, and you had to ford it in five places between our house and Yahoola Church. The water would get up waist deep after a rain. Rupert Hightower used to carry the mail on a motorcycle, and he paid to have the first bridge put in so he could get across when the water was up. It was nothing more than two logs with planks nailed across them, but it kept him dry.

Llenell Jones Sanderson

In 1923 Daddy [Fred Jones, Sr.] started a bus line in Dahlonega with two long cars, and that was the only way many folks had to get to

The Best of "I Remember Dahlonega"

Waiting for a bus at the Dahlonega Bus Station in the 1920s; young boy on arm of chair is Fred C. Jones Jr. *Courtesy of the author.*

doctors' and dentists' appointments in Gainesville and Atlanta. If the drivers saw anybody standing at a mailbox, they knew to stop and pick up prescriptions, which they took care of getting filled and brought back on their return trips. Daddy also instructed his drivers never to pass up a North Georgia College cadet hitchhiking back to Dahlonega whether he had money to pay or not. Daddy always met every bus that came in, day or night, and if somebody didn't have transportation to where they needed to go, he provided taxi service.

Parley Kanaday

I can remember when there was only a small section of pavement around the Dahlonega Square. U.S. Highway 19 was graveled but could still get very muddy. When roads in this area were first asphalted around 1920, it was done as an experiment to see if the asphalt would hold up under the cold. Ed Rivers was known as "the asphalt governor" because this took place during his administration.

Getting from Here to There, Back Then

Helen Head Green Remembers Learning to Drive a T-Model

My father [Dr. Homer M. Head] was the fourth generation of Heads in Lumpkin County. His great-grandfather [James Head] was killed while helping raise a house for a new family in the community. A log rolled off and fell on him. By the time Daddy came along, the Heads were living in Yahoola Valley, where his father had a pretty farm on Yahoola Creek.

I remember hearing Daddy talk about walking to school when he was a boy. In the winter it got dark before he could get home, and hearing the panthers scream up on the ridges scared him so badly that he fairly flew home.

After Daddy graduated from North Georgia Agricultural College in 1891, he spent some time out West, then known as Indian Territory. When he returned to Georgia, he was accepted into the medical school at Augusta, but he had to alternate going to school and teaching to earn the money for the next quarter's tuition. He earned his medical degree in 1900.

Mama [Nina McClure] grew up on the Etowah River, where her old home is still standing. I've always loved the story of how she and Daddy met. Mama was visiting in Dahlonega with her sister Minnie [Mrs. John Moore] when she came down with a terrible cold. In those days colds were treated with poultices smeared with the most horrible, smelly, greasy concoctions you can imagine. Everybody had their own private formulas for making them. Clothing worn over the poultices were ruined by the greasy, staining medicines, so Mama naturally put on her oldest, most faded gown after Aunt Minnie fixed the poultice on her chest.

As Mama was getting back into bed, Aunt Minnie informed her, "By the way, I've called Dr. Head to come take a look at you." Mama sprang up to put on a more attractive gown, but it was too late; Dr. Head was already at the door. This medical house call ended in marriage in 1909. Many years later Daddy remarked to Mama, "Nina, I've seen lots of sick women and lots of ugly gowns in my day, but that gown you had on the first time I ever saw you was the ugliest garment I've ever seen in my whole life!"

Daddy taught Mama much of what he knew about medicine and healing, and she became his right arm. He was twenty years older than Mama, so he depended on her more and more as he grew older.

When I was little, Daddy was still using a horse and buggy to make house calls. Sometimes he would let me ride with him and stand on the dashboard that ran across the front of the buggy. How I loved to stand

The Best of "I Remember Dahlonega"

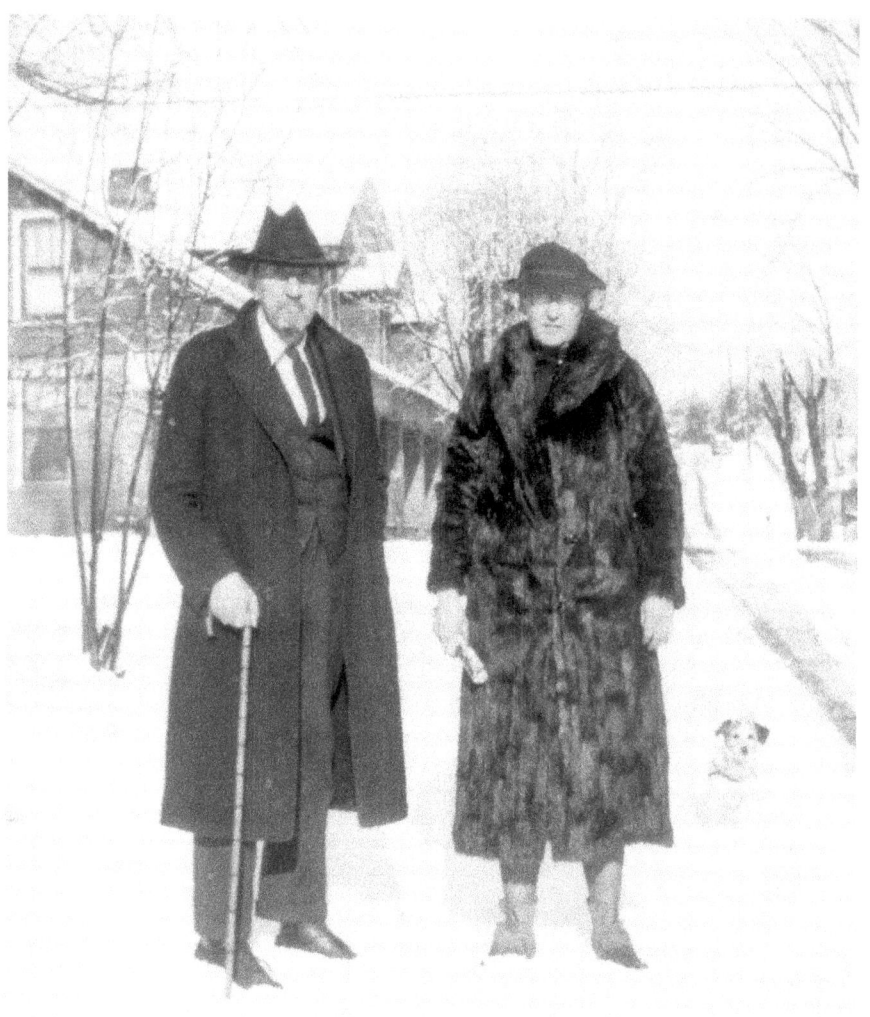

"Doc" and "Aunt Nine" Head. *Courtesy of the Dahlonega Gold Museum.*

there and pretend I was driving the horse! Once when we were driving along a narrow, crooked road, a rock rolled down the mountain and hit one of the wheels. The horse was frightened so badly that he jumped and began to gallop, causing the buggy to lurch. I went over the dashboard to the ground, and the buggy ran over me. By the time Daddy could get the horse stopped and ran back to see about me, I was lying very still in the middle of the road. He thought I was dead, but I just got the breath knocked out of me.

Getting from Here to There, Back Then

When I was about twelve, Daddy got a T-Model car, and there is nothing as much fun as driving a T-Model! It had three pedals: a clutch, a brake and a reverse. There were two levers on the steering wheel: one was the spark advance, and the other was the gas lever. There was a box of coils connected to the spark plugs sitting up front. If they got wet, the car wouldn't crank, so if it rained, they had to be covered. The motor had to be hand cranked in front, and broken arms were common when the motor backfired, causing the crank to spin wildly.

I used to practice driving while Mama and Daddy were away. I would drive up the hill on our street in low, then let the car roll back down until I learned how to change gears. Changing gears on a hill was a big accomplishment. Mama knew nothing about the driving I did on my own, so when she decided it was time to teach me to drive, she was surprised to discover how quickly I learned to change gears without the motor choking!

I once found three gold nuggets on the sidewalk right in front of our house. They had washed down from some dirt that had been dug out of the ditch and piled up beside the street. The expansion joints in the cement had caught the nuggets as effectively as riffle bars in a gold miner's sluice box!

Growing up in Dahlonega was a joy. Perhaps I should say growing up with Dahlonega, for I remember the town when there were no paved roads or public water or sewage. Electric lights were unreliable. They might come on or they might not, so we always kept lamps and candles nearby.

Clarence Cochran Remembers When His Dad's Mail Car Floated Down Bull Creek

My father [Henry Buchanan "Buck" Cochran] was born in 1885 on top of a mountain west of Dahlonega near Cochran Falls. Dad was a country schoolteacher and farmer out in the Nimblewill area of the county until 1919, when he received his appointment as a rural mail carrier. That's when we moved into Dahlonega.

In those days mail delivery was strictly horse and buggy. We kept two horses because one couldn't make it every day. Dad loved his horses and always took good care of them. My brothers Price and Archie Lee and I helped him grease the buggy every day.

Roads were terrible back then. Many RFD [Rural Free Delivery] carriers would soon quit, but Dad said he had three boys to

The Best of "I Remember Dahlonega"

"Buck" Cochran was a rural mail carrier in Lumpkin County for thirty-seven years; photo made by Charles Stargel in the 1920s. *Courtesy of the author.*

educate. My brothers and I all paid our way through North Georgia Agricultural College by substituting on his mail route when we got old enough.

Our favorite horse was named Hattie. If the red flag on a mailbox was up, Hattie knew to pull over and stop without any other signal. If the flag wasn't up and there was mail for that box, a gentle pull on the rein told her to pull over and stop in just the right spot.

Even after Dad got a car, he still carried the first part of his route by horse and buggy, since it was unpaved and impassable by auto in bad weather. Then I'd drive the T-Model Ford to meet him and take the horse and buggy home while he drove the paved portion of his route by car. Sometimes I took a notion to ride with Dad in the car. In that case we left the buggy and harness at Joe Dyer's store about seven miles east of town and turned old Hattie loose to go on home by herself.

Dad's first car was a 1922 T-Model Ford. My job was to see that the proper tools were kept in the car: a jack and tire tool, quick patching for inner tubes (tires back then were not a whole lot bigger than bicycle tires), a pair of pliers, some hay bailing wire (the T-Model was such a simple machine that if the steering mechanism came loose, you could just wire it up until you got to a garage) and a bar of Octagon soap, which would temporarily stop a radiator leak caused by rough roads.

Getting from Here to There, Back Then

Bull Creek was a small stream until it rained hard. Then it could get up high the quickest of any creek I've ever seen. One day we came to Bull Creek just after a heavy rain. Dad said, "I believe I can make it." "No, you can't," I insisted. "Let me out." Sure enough, the rushing waters carried the car downstream just like a cork with Dad and the mail inside!

I crossed the creek on a foot log and went to get Mr. Charlie Stringer to bring his mules and pull the car out. When our car broke down on the route, as it frequently did, and I couldn't repair the problem, all we had to do was send for Charlie Abercrombie. Then he or one of his sons would come get us fixed and on the road again.

Most people out in the county had no way to town, so Dad frequently picked up medicine and delivered it along with the mail. Folks appreciated that, and at Christmastime he would find a gift in almost every box.

By the time I was eighteen, I was Dad's official sworn-in substitute. The main thing I learned was to be kind and courteous to all the patrons. I also learned that it took tough horses, tough autos, and tough men to carry the mail back in those days.

Elizabeth Moore Remembers When Woody Gap Road was Built with Picks and Shovels

I married Henry Moore and came to Dahlonega as a bride in 1925. That was also the year that Henry and his father contracted to build the road from Stonepile Gap through Woody Gap to Suches. Before that, the only way to get to Suches was on Grassy Gap Road.

Henry and Joe Boyd had already surveyed and come up with a route that wouldn't be too steep for the cars of that day to navigate. There were no bulldozers or other road machines then. All the work was done with picks and shovels and wheelbarrows. Dirt was moved by drag-pans pulled by mules.

Most of the forty or fifty men who built the road walked to work. The pay was two dollars a day for those who could do a man's work. Henry and I were up until midnight Friday night doing payrolls so the men could be paid in cash on Saturday. This was at the beginning of the Depression, and there were few other payrolls in the country, so men were happy to get the work, as hard as it was. Delegations were always at the capitol in Atlanta, begging for roads—not just the roads themselves but also for the work they provided.

One of the biggest problems was cutting through rock so hard it would break one drill after the other. A lot of it had to be blasted with dynamite, which Henry's brother Johnny hauled from Gainesville in a

The Best of "I Remember Dahlonega"

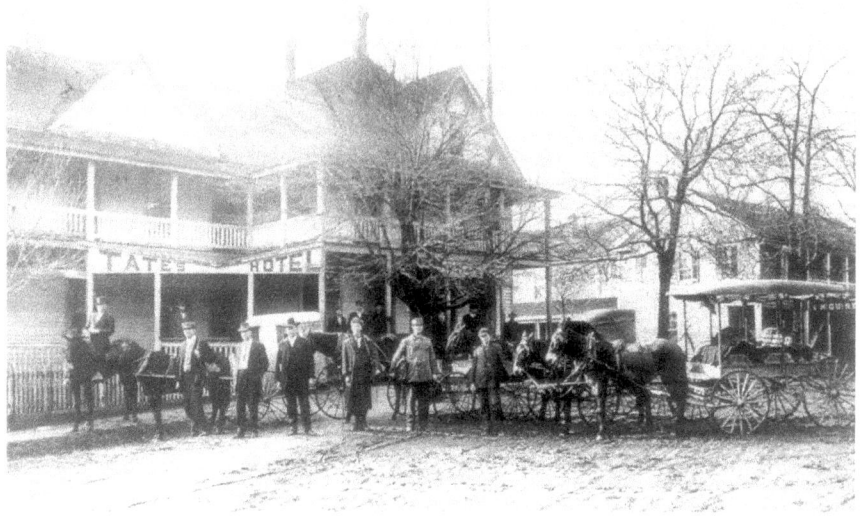

Mail carriers gathered in front of the Dahlonega post office (located in the Tate Hotel 1901–1914) before beginning their routes. *Courtesy of the Dahlonega Gold Museum.*

Model-T, chain-driven Ford truck with solid tires. The road to Gainesville at that time went by way of Quillian's Corner and was very rough and winding, but that never seemed to faze Johnny. He once picked up a hitchhiker, who had to hold onto the seat for dear life. "Boy, this road sure is rough," the hitchhiker gasped. "I hope that whatever you're hauling back there won't break." "Nope, it won't break," Johnny replied. "It's just dynamite." There was no door on the Model-T to slow down the pale hitchhiker as he jumped out without another word!

Most of the men took cover when they heard the cry, "Fire in the hole!" meaning that dynamite had been detonated, but there was one man who never would run—until the time when the roots of a flying stump caught his overalls and ripped them off him!

About a mile below Woody Gap, you can still see rock with a white streak in it. It is now oxidized, but when the work force was cutting through it, it was brilliant with amethysts. Another place they hit shale rock full of hibernating rattlesnakes. Hundreds of snakes had to be killed before work could continue.

The men worked all year, even through the bitter cold of winter, and when the road was finished the following summer, there was a big celebration complete with barbecue and a string band. Everybody from Suches and many people from Dahlonega came out for the occasion. I

Getting from Here to There, Back Then

Elizabeth Moore beside T-Model ca.1925 when her husband Henry was contractor for the Woody Gap Road. *Courtesy of Billy and Beth Moore.*

was told there was even a ten-gallon keg of whisky, which was kept out of Mr. John Moore's sight, since Henry's father did not approve of liquor.

On many other mountain roads, the grade was so steep that it was common practice to tie a tree to the back of the car to drag and slow the vehicle down without burning out the brakes. I can remember having to do that when we went to Amicalola Falls to gather chestnuts. Families living at the foot of a mountain didn't have to go far to gather firewood! The carefully designed gradual grade of the Woody Gap Road eliminated the need for such makeshift extra brakes. Even today, people who know roads say that the Woody Gap Road is an engineering marvel. The original culverts are still in use as is the fine rockwork done by rock masons Henry and Frank Ridley. It is all dry-stacked without any mortar.

In addition to being contractor for the Woody Gap Road, Henry was also inspector for the Neel's Gap Road, which had been started earlier but then abandoned. That road was completed and opened the same day the Woody Gap Road was begun.

Being present for the building of the Neel Gap and Woody Gap Roads was a wonderful introduction to Lumpkin County for me. Many of the people who worked on the roads have remained friends through the years.

8.
Making Moonshine

Making moonshine was a way of life for many mountain men in years past, especially during the lean times when it was virtually the only way a man could make enough money to pay his taxes and buy his children shoes.

Despite the Prohibition movement, which deplored the evils of liquor and sought to outlaw it, making whisky was a reputable and legal profession well into the twentieth century, and moonshiners took great pride in the quality of their liquor. Many of them were descendants of immigrants who came to the New World in search of the freedom it promised, and they considered Prohibition a violation of their basic rights.

Even after Prohibition was repealed in 1933, the manufacture and sale of alcohol continued to be illegal in the state of Georgia without a government license. The cost of the license and paying alcohol taxes cut so deeply into their profits that many mountaineers continue to bootleg.

It was a cat-and-mouse game in which the moonshiners frequently had to outrun the law to get their product to market without being arrested. Consequently they hired mechanics to "soup up" their engines and build suspension systems that could not only carry heavy loads undetected but also handle sharp curves at high speeds. When police cars were equipped with radios enabling law enforcement agents to call ahead and set up roadblocks, moonshining declined and bootleggers began to think of another use for their fast automobiles: stock car racing.

Making Moonshine

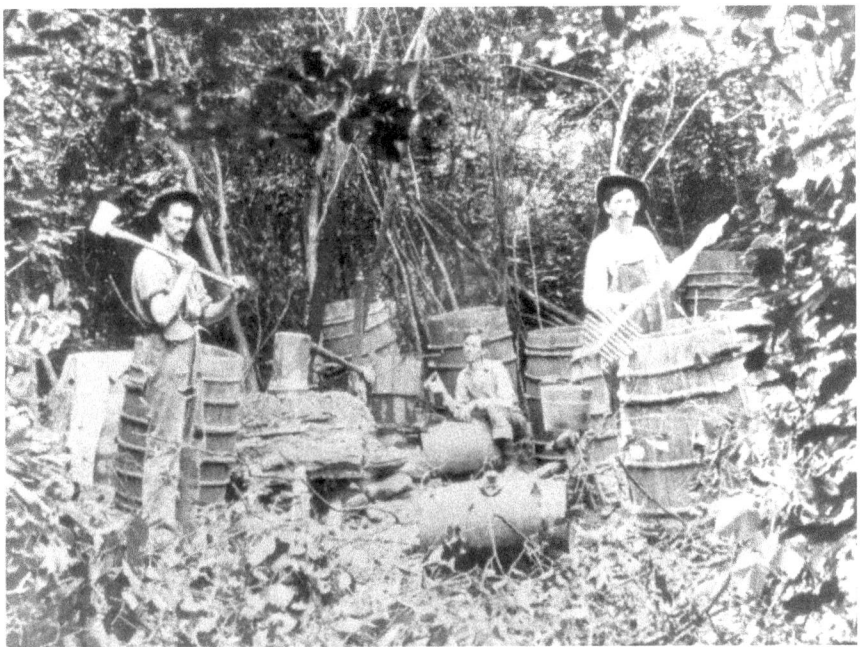

Making moonshine ca.1899. *Courtesy of the Georgia Department of Archives and History.*

Larry Odum Remembers Sara Christian, the First Woman Driver in a NASCAR Stock Race

In its early years stock car racing was a chaotic affair for drivers, promoters and fans alike. Popular race car driver Bill France had the idea of setting up an organization to establish rules to govern racing and started looking for people to provide the necessary financial backing.

It was no secret that Frank Christian had been a moonshine runner in Lumpkin County. He still loved fast cars even after he moved to Atlanta and had a wife and child. Aware of Christian's enthusiasm for racing, Bill France approached him with his idea of a racing organization and offered him half of the new company's stock if he would invest money to help get it started.

After some hesitation, Frank loaned Bill $500 to establish the National Association for Stock Car Auto Racing [NASCAR], but he must have had doubts about how successful the organization would be, for he declined the offer of half-interest in it. At the time NASCAR was established in

The Best of "I Remember Dahlonega"

1947, all Frank wanted was to get his money back. In later years when NASCAR became so big, he always regretted his lack of foresight.

Frank owned several stock cars, which were driven by a number of good drivers, including Tim, Fonty and Bob Flock, Hershel McGriff, and the legendary Curtis Turner. When the Flock brothers were planning to open a new track in Morrow, Georgia, they and the Christians were brainstorming ways to get more people to come out for the races.

"Why don't you have a women's race?" Frank's wife Sara suggested. "I'll drive."

Large crowds did indeed turn out to see the first ever "Powder Puff Stock Car Race." Also driving in the race were Sara's sister Mildred and the Flock brothers' sister Ethel. Sara chose "7/11" as her number because her son Tommy was seven months old and her daughter Patricia was eleven years old at the time. Sara herself was thirty. She won that race and was so exhilarated that she wanted to continue racing—but not merely as a powder puff driver.

After her first race, Sara knew she wanted more of it. She went on to become the first woman to drive in a race sponsored by NASCAR and competed against some of the best men on the stock circuit. In the two hundred-mile feature at Langhorne, Pennsylvania, in September of 1949, she raced against forty-seven men, including top-notch stars from all over the country, and finished sixth.

In October Sara took fifth place in the two hundred-lap event at Heidelburg Speedway in Pittsburg, but in November she collided with another driver at Atlanta's Lakewood Speedway and flipped her Oldsmobile on its roof. Fortunately she suffered only a bruised chest.

On February 10, 1953, Sara was among the few drivers who broke the measured mile record at Daytona Beach, which involved a turn around a barrel and never averaging less than one hundred miles per hour. "I wasn't treated like a woman on the track, and I wouldn't have had it any other way," she told a reporter in later years.

Later that year Sara lost control on a curve at Lakewood and flipped her car seven times. That mishap broke her back and virtually ended her racing career. Her son Tommy described the accident in an interview in the *Gainesville Times* many years later, saying, "She raced again a few times because she said she couldn't stand to be afraid of racing, but that wreck made her realize how dangerous it was. She had me and my sister Pat, so she decided to take care of herself for us."

After Sara retired, she and Frank moved to the old Christian farm on Highway 52 west of Dahlonega, where Sara once more found herself behind the wheel (of a tractor) as she and Frank farmed the bottom lands along the Etowah River. They also ran the Cherokee Motel in town.

Making Moonshine

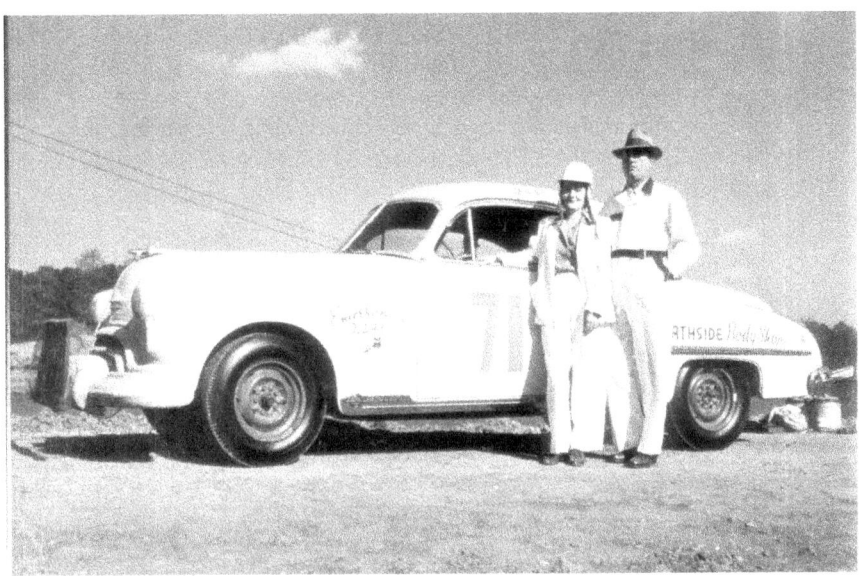

Sara and Frank Christian, 1953. She wrote the following words on the back of this picture: "This is my last race car. About 45 min. after this was made, it was a total (almost) wreck." *Courtesy of Sally Bryant Kelly.*

Frank Christian was one of the major car owners during the early years of NASCAR, and his cars and drivers were always contenders for the win. Many times Frank had two or more entries in a single race, and his cars, sponsored by big name companies, won many events. His 1955 Chevrolet won at Columbia, South Carolina, on March 26, 1955, giving Chevrolet its first NASCAR Grand National win.

My personal interest in racing was inspired by the Christians and my father, who was also a stock car driver. The early stock car drivers were much like modern test pilots: daredevils who risked life and limb to experiment with new means of going faster. Frank and Sara were ahead of their time in racing, and those of us who love stock car racing today owe the Christian family a debt of gratitude for their contributions to this great sport.

Note: Sara Christian's granddaughter, Sally Bryant Kelley, remembers her grandmother fondly. "She was very feminine and soft-spoken, and you would never have guessed that she had been a race car driver," Sally reminisces. "I spent a lot of time with her, but she never spoke much about her racing. I've learned everything I know about it from reading newspaper clippings. Her trophies and other memorabilia are on display in the NASCAR museums in Darlington, South Carolina, and Talladega, Alabama."

The Best of "I Remember Dahlonega"

Homer Rider Remembers Running from Revenuers

Just about everybody had a still back in the '30s, and Daddy could build the best stills of anybody around. Anybody wanting a still knew to get Hubert Rider to make it for them. Actually, he had me doing most of the work while he did the talking!

Dad made all kinds of whisky: rye, corn, brandy and what was called "hog whisky" that was made in a big ol' aluminum drum that looked like a hog. The best whisky was what was called "double and twisted" because it was run through the worm [a tube that condenses steam into liquid] a second time.

When the law came to bust up a still, everybody ran to keep from being arrested. My brother Carl was always on the sickly side, but he could outrun the law any day of the week!

No matter how many stills the revenuers busted up, they never stopped folks from making moonshine, because that was about the only way they could make enough money to feed their families. Sugar was cheap (three cents a pound) back in those days. What finally put an end to moonshining was the rising cost of sugar. Moonshiners abandoned their stills when they couldn't afford to run them anymore.

Herman Caldwell Remembers Telltale Smoke

The only telephones in the area where I grew up north of Dahlonega belonged to my daddy [Monroe Caldwell], Bill Gooch and Bill Lance. They had to be cranked by hand. Sometimes the phone would ring, and it would be Sheriff Davis telling Daddy, "Monroe, the cattle are coming. You'd better get your corn out of the way." That meant the revenuers were on the way! Daddy, like lots of other folks in these parts, made moonshine, and mountain men looked out for each other.

I can remember gazing across Yahoola Valley from Woody Gap early in the morning and seeing smoke coming up from dozens of stills. I knew it was from stills because there were no houses in the areas where the smoke was coming from!

9.
Doing Business in Dahlonega

It wasn't long after the first miners' cabins sprang up that commissaries began appearing to provide supplies for the miners. Local merchants had to make supply runs to Gainesville to bring back merchandise to sell. The forty-five-mile round-trip wagon trip took three days. Most customers bought on credit and paid their bills at the end of the month, requiring that merchants keep records of purchases in big ledger books.

Other businesses appeared as people with a particular talent found their services in demand by others less skilled in that area. Anyone who could put in a gristmill to grind his corn or a syrup mill to process his cane did his neighbors' corn and cane as well for a share of the product. A man who could temper steel was much in demand to make and repair farm tools. When a beautician moved to town, women began to abandon their simple buns to have their hair cut and curled.

MEMORIES OF EARLY STORES AND SHOPS

Ola Smith Moore

Moore's Store was in operation from 1920 to 1962 and sold everything but cigarettes and fish hooks because Papa Moore didn't approve of smoking and thought fishing was a waste of time. His son Robert delivered meat to local residents before breakfast when he was a youngster. Since there was no refrigeration in those days, meat had to be sold and delivered quickly. Merchandise was still frequently paid for with gold dust and nuggets mined by the customers. The store had a special scale for weighing gold.

To Papa Moore's dismay, Robert took up both smoking and fishing. After he bought the store in the mid-'40s, he proudly mounted a sailfish he caught while deep-sea fishing in Florida and hung it on the balcony railing to be admired by his customers.

The Best of "I Remember Dahlonega"

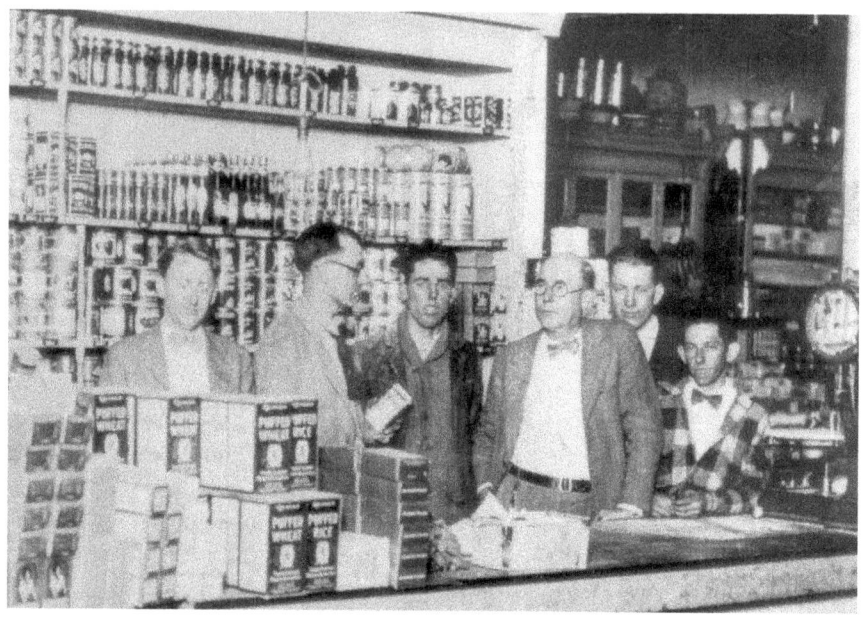

Interior of Moore's Store; (left to right) Robert Moore, Hubert Tate, Grady Ash, Will Worley, Buster Kenimer and Bert Walden. *Courtesy of Georgia Department of Archives and History.*

Vee Dyer Doyle

My parents [William Joseph Dyer and Mary Jarrard Dyer] operated a store east of Dahlonega on the curve of the road near Mt. Gilead Church. The community is shown on old maps as Garland, but after my parents bought the property in 1907, it became known as Dyersville. Our store carried everything you could think of, from kerosene to corsets. Sometimes children would come in and ask for one egg's worth of candy. Crackerjack was a popular item, and I was as eager as our customers to discover what prizes were in the boxes of caramel-covered popcorn. The store had a big bell outside the door for customers to ring for service when everybody was off doing other things.

Edna Lipscomb

When we moved to Dahlonega in 1922, my husband "Doc" [D.H. Lipscomb] was the only pharmacist above Gainesville. Back then doctors dispensed their own medicine, so it was a couple of years before Doc got much prescription work. Then people started calling him in the middle of the night to fill a prescription for them! Sometimes folks tried to get him

Doing Business in Dahlonega

to diagnose their ailments and prescribe medication instead of going to a doctor. He not only knew and loved everybody in town; he also knew all their symptoms!

George Lipscomb

I worked at my dad's drug store after school, and I remember "jerking sodas" when I had to stand on a crate to reach the fountain. I liked watching Dad grind the pill ingredients with a mortar and pestle, mix them with a liquid and roll them out into a sheet, which he then cut into small sections and rolled into pills.

Woodrow Parks

During the 1920s Papa [Frank Parks] ran a meat market and grocery store called the Dahlonega Cash Store in partnership with M.H. Garrett and brothers Boyd and Will Housley. People could phone in their grocery orders (our number was 3-6) and have their groceries soon delivered in a one-horse wagon. The store opened early, and customers would frequently order a loaf of bread and have it in time for breakfast. Folks gathered around the store's potbellied stove until we closed at eleven o'clock on Saturday nights.

Doris Kenimer

I came to Dahlonega in 1934 to operate what was then the only beauty shop in town. In those days permanents were "heat waves," and hair was curled by a tall machine with heaters that pulled down and clipped over the rollers in a customer's hair. The process took a good two hours. I was giving Maude Hightower a heat wave one day and had just hooked her up to all thirty of the heaters when the fire siren sounded. She became very worried that it might be her house on fire and could hardly sit still in the chair. I knew the fire would be out before I could get her unhooked, so I called "Central" and was able to reassure Maude that her house was not in danger.

Ruby Gooch

When I was a small child, my favorite thing to do was to stand on a chair and comb my mother's hair. That was back in the days when we used to roll our hair up on tin cans. We cut strips out of the cans and wrapped them with lots of layers of brown paper to keep them from cutting our

The Best of "I Remember Dahlonega"

Lipscomb's Drug Store. *Courtesy of the Dahlonega Gold Museum.*

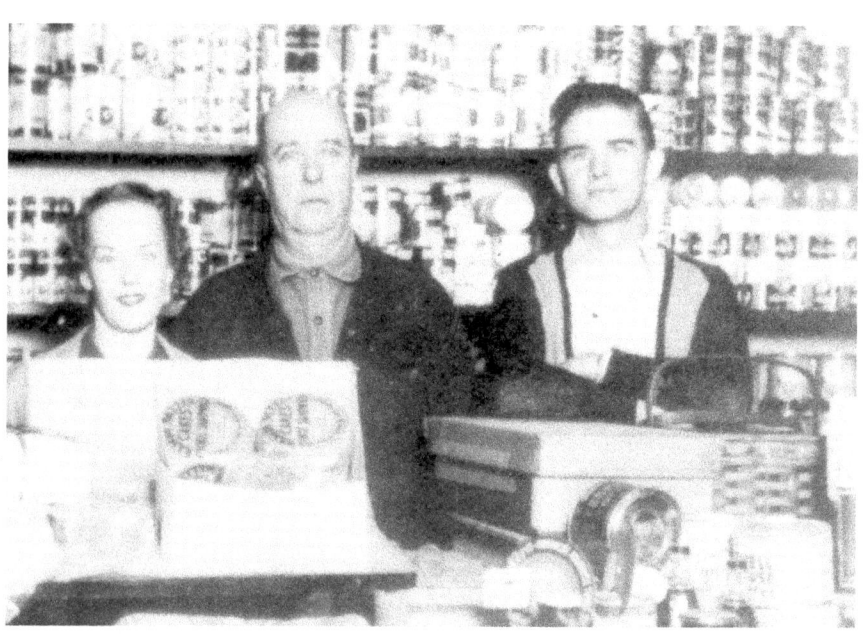

Parks & Garrett Store in the 1920s; (left to right) Fannie Belle Garrett (Ragan), M.H. Garrett and Woodrow Parks. *Courtesy of the author.*

Doing Business in Dahlonega

hair. I always looked for Prince Albert tobacco cans because they were a softer metal and easier to cut. I also remember rolling hair on old rags before we had real rollers.

When I started my shop in the late '50s, the old dryers blew so hard that I had to tie hairnets over customers' hair to keep the curlers from blowing out. The air was so hot I had to put cotton in their ears. You couldn't buy conditioners, so I had to make my own out of olive oil or mayonnaise. The hair business is much easier today than in the past.

Vernon Smith

My parents [H.B. and Bessie Smith] bought property just south of the square in 1922 and opened the Smith House Restaurant and Hotel. Even then there were lots of tourists coming up to enjoy the mountains, and many of them would stay several weeks at a time or even all summer. The Smith House became popular almost immediately, thanks to the bountiful table of food cooked and served home style by my mother, with the assistance of Mary Strickland and Virstee Howell. The cost of a meal in those days was thirty-five cents. There were wood stoves in the lobby and in some of the rooms for winter guests. One of my jobs was to cut and split wood to keep them burning. I also had to milk the two cows that supplied milk for the restaurant.

Eli Abee Remembers "Diving for Pearls" at the Smith House

In 1948 when I was twelve years old, I applied for a job at the Smith House. Manager Fred Welch told me that he only had one position available: a job he referred to as "diving for pearls." My joy in getting a job with such an important-sounding title was so great that I accepted immediately without asking any questions.

Since this was my first ever job, I rushed home as fast as my legs could carry me to share my good news with Mama. That night I could hardly sleep for thinking about my important new job. Mr. Welch appeared very glad to see me when I reported to work bright and early the next morning. Putting a clean apron on me, he took me to a sink stacked almost to the ceiling with dirty pots and pans. "Here's your ocean of pearls, Son," he told me. "Start diving."

My bubble burst very quickly about my oh-so-very-important job, and I began searching my mind for an excuse to get myself gracefully out of what I had gotten into. The first one that came to mind was, "Hallelujah, I'm too short to reach the sink! That will get me out of this predicament for sure." I pointed this out to Mr. Welch, thinking he would surely have to assign me to another job, but he quickly solved the problem by placing two empty Coke crates in front of the sink for me to stand on. I don't know how the expression "diving for pearls" got started, but I later discovered that it is familiar kitchen jargon in the food industry.

I had been "pearl diving" for three months when Fred took me aside to tell me that because I was doing such a good job, he was going to assign me more duties. These consisted of shucking corn, cutting okra and ringing the dinner bell at meal serving time. Soon I was being trained in food preparation by the restaurant's three cooks: Fred Riley, the head cook; Jack Beasley, the fry cook; and Ester Austin, who taught me how to prepare the famous Smith House rolls and cobblers. I was very privileged to work with those three fine African Americans. By the time I was fourteen, I had progressed to the position of a main cook myself.

When I started to work at the Smith House, I never dreamed that it would lead to a career in food service. Fred and Thelma Welch became a second set of parents to me, and the values they taught me have remained with me throughout my life. Over the years, I have often wondered how many other young people Fred has given the opportunity to "dive for pearls."

Fred Butler Remembers Tempering Steel in his Dad's Blacksmith Shop

My daddy, Will Butler (1874–1935), was a fine blacksmith, and neighbors brought their tools to him to be sharpened, everything from plows and axes to picks and drawing knives. Daddy recycled old metal to make shovels and firedogs and hand axes as sharp as a razor. He taught me how to temper steel by heating it to a cherry red and then cooling it to just the right temperature before plunging it into water. The steel will turn gray, then blue, and there's a real art to knowing just when it's ready. If it's too gray, the steel will shatter; if too blue, it will mash.

I learned at a very early age not to pick up everything I saw around the blacksmith shop and to be careful where I stepped. Pieces of metal might lose their color but still be almost as hot as if they were red!

Doing Business in Dahlonega

Eli Abee in his cook's hat when he was working at the Smith House. *Courtesy of the author.*

In the days before jackhammers, miners and well diggers had to cut through rock using hand drills, which were nothing more than sharpened pieces of steel hit from above with hammers. Believe me, that was a man's job! Daddy sharpened many such hand drills, using a hand bellows to heat the steel.

The man who swung the hammer on these hand drills developed muscles like steel, but the man who held the drill had to have nerves of steel. A right-handed swinger sure needed to know what he was doing or he would hit the hand of the man holding the drill to steady it, especially working in close quarters like in a well. I did plenty of both in my younger days.

In addition to being a blacksmith, Daddy also had a syrup mill and made syrup for everybody around. It was my job to prod the mules that turned the steel rollers that squeezed the juice out of the cane. Another one of my jobs was cutting firewood and hauling it in. If I didn't take care of the wood, Daddy took care of me! I also pulled fodder and took care of the mules. We didn't ever run out of things to do. Getting off to go fishing on a Saturday evening was a pretty big deal.

I went to Yahoola School first and later boarded in town while I attended the Dahlonega Public School. There was no such thing as a lunchroom in those days, so we carried our lunch to school in large pails. I can still almost taste the biscuits and salt-cured ham and baked sweet potatoes my mother

The Best of "I Remember Dahlonega"

The Will Butler Family ca.1915. Fred is the small boy on the left front. *Courtesy of the author.*

used to pack for me when I was still a lad in knee britches. I hated wearing those knee britches and was tickled to death when I finally got old enough to be allowed to wear real pants!

Back when I was attending a one-room school, I never thought that I would grow up to be first a schoolteacher and later superintendent of schools [1948–56]. It was during my administration that the state Board of Education decided to consolidate all the county schools and bus students into town.

When I start thinking about the past, lots of memories of what life used to be like come to mind. I remember when the only way you could get coffee was to purchase green coffee beans, which you had to parch and grind in a hand coffee grinder.

We slept on feather beds made from duck, chicken, or goose feathers. These mattresses were laid on top of straw ticks stuffed with wheat straw. Clothes were handmade, and shoes were repaired at home by hand. Farming tools were also handmade: plows, briar-hooks, hand axes and froes for splitting boards to cover houses. Soap was made from grease and potash or lye. Lye was made by pouring boiling water over clean ashes.

Before the days of refrigeration, the only way to keep food from spoiling was to let it down into the well or keep it in a spring or cellar. My daddy had a covered spring enclosed with pine palings (split pieces of

Doing Business in Dahlonega

wood). If the spring wasn't enclosed, the pigs or dog might want to share your food with you!

I remember all the corn shuckin's and log rollin's we used to have. When a farmer needed more land, he would invite the neighbors in to help him cut the trees and roll them together to be burned. Of course, you still had the tree stumps and roots to deal with, and I remember how hard the handles of the plow would hit you when the blade caught on a solid hickory root! The best part of the shuckin's and log rollin's was the eating afterward. My mouth waters when I remember long tables covered with chicken and dumplin's, sweet potato pies, pumpkin custards and the like.

When kudzu was first introduced in Lumpkin County, I thought I had found the perfect answer to hillsides washed away by erosion and hydraulic mining, and I set out quite a few plants. It took it a while, but after the kudzu finally took off, it not only covered the ground; it covered the trees and everything else in sight! It also created a wonderful habitat for groundhogs.

10.
The Three Rs: Reading, 'Riting and 'Rithmetic

The first school in Dahlonega opened in 1835 and was called the Dahlonega Academy. It was abandoned when North Georgia Agricultural College was founded in 1873 and an elementary school was established within the college. Most rural children attended small schoolhouses scattered throughout Lumpkin County. Many of them walked a mile or more to a one-room school where one teacher taught all subjects and all grades. The only qualification required to teach at that time was the ability to pass an examination, and teachers were sometimes younger than some of their students. School was in session only during the times of year when children were not needed at home to help with the planting and harvesting of crops.

MEMORIES OF GETTING EDUCATED IN ONE-ROOM SCHOOLHOUSES

Monteen Souther

My grandmother, Almira Baugus Abercrombie, attended Mt. Gilead School right after the Civil War, and she used to tell us how they made their own pens out of sharpened goose feathers. They also made ink by pressing the juice out of "ink balls" that grew on oak trees and adding some copperas [a compound used for dyeing]. Students sat on seats made of big split logs with wooden legs at each end. They wrote on desks made of split log shelves fastened to the wall.

Granny Almira was a good speller, and she said it was because she was taught to pronounce each syllable as she spelled a word. They used to have spelling bees in which students stood in line to spell the words the teacher gave them. If you missed a word, you had to go to the back of the

The Three Rs: Reading, 'Riting and 'Rithmetic

Mail carrier "Buck" Cochran delivering a letter to Almira Abercrombie when she was ninety-seven years old. *Courtesy of the author.*

line, and the next student in line got to try to spell the word correctly. At the end of the school year, the teacher usually gave a prize to the student with the most "headmarks," and Almira was usually the one to earn it.

Anapearl Walker Seabolt

School was only in session for five months out of the year when I first started teaching, but it was later increased to seven months. I taught all ages and all subjects in one-room schoolhouses, and only occasionally did I ever have a problem with discipline. Children then were pretty good to do what their parents and teachers said.

There were no school buses back then, and the children sometimes walked two or three miles to school. I boarded with one of the students' families and paid ten to twelve dollars a month room and board out of my salary of fifty dollars per month. We all took our lunches to school with us, and the lady of the house where I was boarding packed one for me. We usually ate leftovers from supper the night before, mostly vegetables. People didn't eat sandwiches then like we do today. Instead, we ate biscuits filled with syrup and okra and even turnip greens.

The Best of "I Remember Dahlonega"

Albert Christian

When I started school in Auraria, I walked two miles in the morning and two miles home in the afternoon when school was out. We had trails that we followed because there weren't many roads back then. There were only nine grades, and they were all in a one-room schoolhouse. I went through seventh grade, which was considered high school at that time.

You learned a lot in school then. The teachers really made you stay with it. I think we learned more in seven years than they teach in twelve now because we were taught to think for ourselves and figure out ways to get things done. That really came in handy for me when I got older. If I couldn't get something done one way, I would try different ways until I did get it done.

Loudean Jarrard Seabolt

I started at Lydia School when I was five years old and went through all seven grades there. School started at eight o'clock, and we weren't dismissed until four o'clock, so during the winter months many students left home in the dark and didn't arrive home until the sun was setting. That seems like a long day compared to the hours students are in school today, but we had two thirty-minute recesses and a full hour for lunch. We didn't have individual desks. We sat on long benches with our feet dangling in the air, boys on one side of the room and girls on the other. We wrote in our laps. There were no free textbooks back then, so we children had to work during the summer earning money to buy our own books.

Indoor plumbing was unheard of, and there weren't even any outhouses when I first started at Lydia School. At recess time the girls headed in one direction to a wooded area, and the boys headed in another. We had to carry water from the spring for drinking and washing up. There was always a big bar of Octagon soap on hand to clean our hands and keep the "itch" away.

The teacher kept a hickory stick on her desk to use when needed, but she usually tried other kinds of discipline first. One day I had been talking my head off despite all her warnings. Finally, in exasperation, she drew a circle on the board (a big space painted black on the boards of the wall) and told me to go stand with my nose in it until I thought I could control my tongue. The chalk dust kept irritating my nose and making it drip down the board. It seemed like hours before I got to go sit down again!

The Three Rs: Reading, 'Riting and 'Rithmetic

Governor E.D. Rivers campaigning in Dahlonega in the 1930s; pictured with him are Clynton "Dinky" Fitts (right) and Ben Popay. *Courtesy of the author.*

J. Clynton "Dinky" Fitts

When I was in school, there was no such thing as free textbooks. Governor E.D. Rivers campaigned on the promise to provide free schoolbooks, and he kept his promise. Somebody took a picture of me standing beside him when he was campaigning here in the 1930s, and I remember him saying something like, "Boys, I've given you free schoolbooks; now go on and get a good education."

Clarence Cochran

I remember when "Miss Ida" Avery ran for county school superintendent in 1932 and was elected by carrying 74 percent of the vote. She campaigned in a T-Model Ford Coupe and was the first woman elected to public office in Lumpkin County. She worked to consolidate all the county schools and run school buses to bring students to the main school in town.

Lillie Chester Christian Remembers Early "School Buses"

I was born and reared in Nimblewill west of Dahlonega and never set foot out of that community until I was practically grown. It was settled pretty thick back then.

The Best of "I Remember Dahlonega"

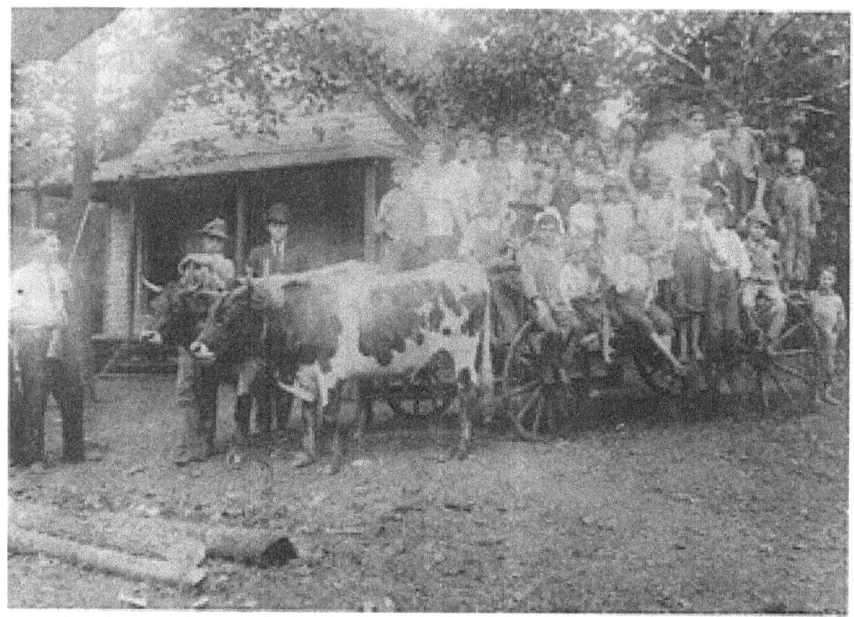

The Auraria "School Bus," driven by Ed Christian ca. 1920. *Courtesy of Sara Sperin.*

We got telephones back about 1910, but we had a nineteen-party line! The families in Nimblewill cut their own poles and built their own telephone lines. If you wanted to call out of Nimblewill, you had to ring one of the "Central" families on either end of the line and get them to make the call for you. We enjoyed having a telephone because it put us in touch with other people.

Lots of people made their own moonshine back then. If revenuers were sighted, you could hear the telephones being really cranked up in warning, and people would talk in whispers over the line asking, "Where are they?" Sometimes when parents were away, youngsters would have fun cranking up the telephones to make everybody think their stills were in danger!

Papa's name was M. Calvin Chester, but I never heard Mama [Icalona Waters Chester] call him anything but "Mr. Chester." She was one of his pupils when he taught at Noonday School in Nimblewill. There were five of us children, and he taught all of us, too. We always thought he was stricter on us than the other pupils.

Noonday's "school bus" was a wagon pulled by a red-and-white steer and a black heifer with a white spot. The wagon and animals were both provided by "Mr. Chester" and were usually driven by my brother,

The Three Rs: Reading, 'Riting and 'Rithmetic

Chalmer Chester. Sometimes there were as many as twenty-one or even more children riding.

When I was seventeen, I moved to Auraria to teach school there for thirty dollars a month. In those days they didn't teach you any fancy techniques for teaching. If you could pass a test, you just went out and did it. Ed Christian was in charge of driving the Auraria "school bus," a big wagon pulled by two steers. Ed also brought wood for fires sometimes, but other times I let school out for a while so the children and I could go get wood to keep warm.

I had been seeing Ed Christian's brother Charlie since before I moved to Auraria, and one Sunday afternoon we up and decided to get married. We were headed for Ben Higgins's house when we met up with him on the road. He was a justice of the peace, and he married us on the spot. I was sitting in a buggy with a big mule hitched to it. The mule was hitched to the buggy, and I was hitched in it!

11.
Having Fun Doing Work

Men, women, and children worked long and hard to keep food on the table and clothes on their backs, and there was little spare time for recreation in years past. The human spirit craves play, however, and the hardworking farming families often found ways to enjoy life and get their work done at the same time. With no store-bought toys available, children were creative in making up games and adapting whatever they could find to provide entertainment.

Memories of Corn Shuckin's, Cotton Pickin's and Fiddling Contests

Fred Hood

> I remember the corn shuckin's we used to have when I was a boy. When the crib got full, the man who grew the corn was put on a rail and carried inside the house. The others would carry the rail on their shoulders, so the man riding the rail had to hump way over to keep from bumping his head when they brought him in the door, especially if he was very tall. I saw my daddy brought in on a rail many a time. I'd give a hundred dollars to have a picture of that. Young people today don't know about such things.

Clydie Trammell

> There was so much work to do that there wasn't much time for play, but on Saturday nights, we moved the furniture out of the way. Then the fiddlers came, and we danced. How I loved to dance when I was young! I once got a prize for being the best dancer.

Having Fun Doing Work

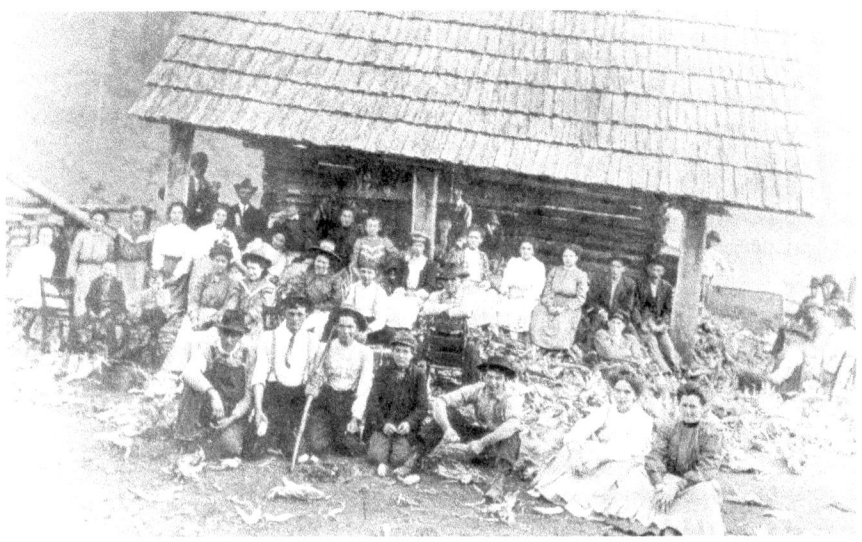

A corn shuckin' ca.1890. *Courtesy of the Georgia Department of Archives and History.*

George Lipscomb

I remember the pickin' and a-grinnin' get-togethers that took place Saturday nights in Will Jones's Store on the square back in the late '20s. People came to sit around under the store's one faintly glowing light bulb and listen to the fiddles and guitars play hymns, folk songs and hillbilly music. I looked forward to Saturdays to listen to the music. I was just a little fellow then and probably wouldn't have been allowed out except that we lived next door.

Fred Burns

When I was a boy back in the '20s, they used to show silent movies in the Price building on the square. It cost me a nickel to get in and another nickel for a bag of popcorn. When one reel ran out, they turned on the lights while they were putting another reel in the projector. Most of the movies were Westerns. There was some sort of recorded music but no speaking. I remember going to movies before I could read the captions on the screen, but somebody would usually read them out loud.

We had to make our own entertainment when I was growing up. We didn't have store-bought toys because there was nothing in the stores to buy even if you had any money to buy with. I must have rolled an old automobile tire a million miles when I was a boy! We played games like "Fox and Hounds," and we climbed trees.

The Best of "I Remember Dahlonega"

C.C. Davis

I remember us boys playing mumbletypeg with our jackknives, rolling hoops, shooting marbles and spinning tops. We put tobacco tags in a ring drawn on the ground and tried to knock the tags out of the ring with our tops. Whoever knocked a tag out got to keep it.

Ethel Price Adams

People used to be more sociable and visited more than they do today. I remember going to lots of candy drawings and dances and quilting parties. Some of our favorite games were playing ball, drop-the-handkerchief, base and marching 'round the lily. The "lily" was a girl, and some boy would bring her out of the circle. If more than one boy wanted to take her out, she got to choose which one to go with.

Mae Smith Ray

Uncle Polk and Aunt Typhrenie used to have an old phonograph with a big horn on it. It had to be cranked by hand, and the records it played were round like pipes. One of the songs was called "The Preacher and the Bear," and when I was little, I was always afraid the bear was going to jump out of the phonograph and get me!

Ralph Fitts

Us children were too busy doing our chores to have much time for recreation, but I remember playing "Fox and Dog." The person who was the "fox" tried to outrun the "dogs" chasing him. We would also climb trees and try to shake each other out. A lot of what is considered recreation nowadays was necessary for survival then. We fished and hunted for food, and we ate rabbit, squirrel, possum and turtles that we trapped. Everybody had to work to keep food on the table. You had to "root hog or die pore," meaning if you didn't work, you didn't eat!

I remember folks gathering for corn shuckin's and candy pullin's. After the sorghum syrup was boiled down, we'd pull and stretch it into ropes. Sometimes all the furniture would be moved out to make room for a square dance. I loved to hear the fiddlers play "Turkey in the Straw." Sometimes there was a fiddlers' convention with judges and a prize for the champion fiddler.

Herman Caldwell

Daddy was as good a fiddler as there ever was in this county and could play anything there was to play. At Christmas and during corn shuckin's,

Having Fun Doing Work

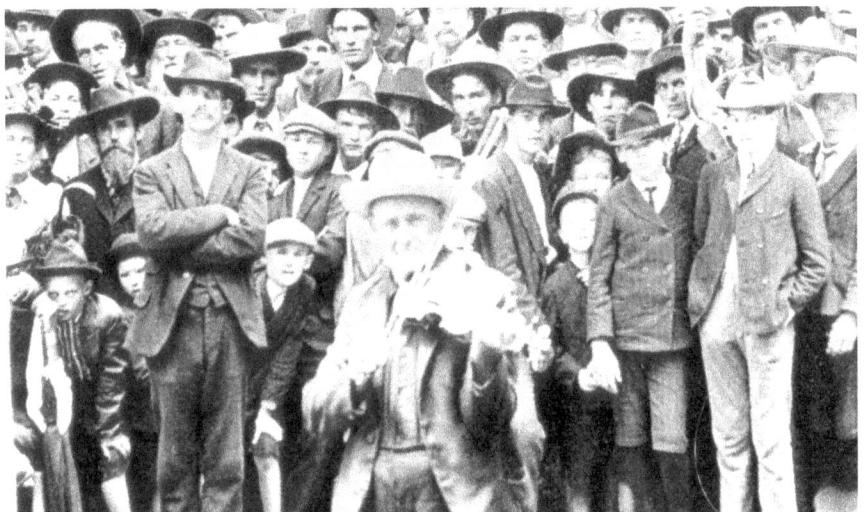

A fiddlers' convention held in Dahlonega ca. 1905. The fiddler is Sheriff W.H. Satterfield. *Courtesy of the Georgia Department of Archives and History.*

we'd have square dances that lasted until 2 a.m. My brothers played the mandolin and guitar, and I played the piano. We had an old-time piano, and I loved playing it better than anything else in the world. One time when I was stripping cane, I got the urge to quit working and go play the piano. Next thing I knew, I had a cane stalk on my back!

Vee Dyer Doyle

Some of the games I remember playing were bending down hickory saplings and riding them up and down like horses; making play houses in the woods and furnishing them with discarded broken dishes; pinning leaves together with small sticks to make skirts and hats for dress-up. We threw balls made of wool threads wrapped around a rock.

Roy Abee

About the only recreation we had when I was growing up was pitching horseshoes and playing "cow pasture ball." We looked forward to when the circus came to town and set up in Tate's pasture. My brother and I didn't have any money, so we had to slip in under the bottom of the big top. We also looked forward to Court Week, when the medicine man came to entertain us with his monkey and organ grinder. Then he would give his spiel from the back of his truck and sell his patent medicines.

12.
Animal Tales

Many of the people in this book have told about the animals that were an integral part of their daily lives: mules that pulled the plow; oxen that pulled wagons and horses that drew buggies; sheep sheared for their wool; chickens that laid eggs for eating and bartering; hounds for leading hunters to game. The following stories are about some extraordinary creatures as remembered by the people who encountered them.

Florethel Satterfield Remembers a Smelly Encounter

During the fifty-five years I was married to Dewey Satterfield, he spoke often of his childhood in Lumpkin County and related much of local customs and culture in the early part of the twentieth century. Many of his memories were so vivid that I began to feel that I, too, had experienced them.

When Dewey was about five years old, he took his hunting dog and went out to find a couple of squirrels or rabbits for the family supper table. Boy and dog soon came upon a large end of a big hollow log, which lay pointed down a slope. The dog dashed down into the log, with Dewey squirming headfirst right after him.

Dewey had armed himself with a long tree branch, which he poked along ahead of himself and the dog. As the trapped and prodded critter tried to squeeze past the dog and boy to make a run for the outside, "Old Sam" [the dog] grabbed a hindquarter and shook. Unfortunately for both of them, the "rabbit" turned out to be a skunk!

When Dewey got home and called his mother from the front gate to explain his problem, she used a long stick to supply him with homemade

lye soap and fresh clothes. His instructions were to bury his smelly clothes in the sandbar in the creek for two days and wash himself and his hair three times. Even the strong lye soap couldn't get rid of the odor, however, and Dewey and his dog were banished to the barn for the next two weeks. Dewey didn't learn until forty years later that a shampoo with tomato juice would have eliminated the smell of skunk.

Oscar Cannon Remembers Charlie Turner's Pet Bear

My granddaddy Cannon went to California to mine for gold when Daddy was just a baby. He wrote my grandmother that he had enough to take care of them for the rest of their lives and was coming home, but something must have happened to him on the way. They never heard from him again or found out what became of him.

I've been living near Turner's Corner [north of Dahlonega at the intersection of Highways 19 and 129] since before the turn of the century. The first bridge wasn't built until 1926, and I remember cars getting drowned out trying to ford the Chestatee River when the water was high. Then somebody would have to bring a team of mules to pull them out. There was a high foot log for people to walk across. The White boys built a station there in 1923 and later sold it to Charlie Turner.

Charlie Turner used to have a pet bear that roamed loose along the river. "Smoky" was so tame that he let children ride on his back, but the sight of a loose bear scared most fishermen and travelers so badly that Charlie finally had to build a cage for him. Charlie was mighty attached to that bear, and when Smoky died of old age, Charlie missed him so much that he went looking for a replacement. He found a man up in Suches who had a bear cub, but he said he couldn't sell him to Charlie because there was a law against buying and selling wild animals.

"Well, if you could sell the bear, how much would you want for him?" Charlie persisted. "I reckon he's worth a hundred dollars," the man replied. Without another word, Charlie put a one hundred dollar bill on a nearby stump, picked up the bear and headed for home, where he raised the cub on a bottle. The new bear was named "Herman" after Governor Herman Talmadge, who frequently stopped to visit with Charlie.

Many people used to stop at Turner's Corner to see Charlie's pet bear on their way up to the mountains. Charlie also had a monkey that was a popular attraction, especially for the young-uns.

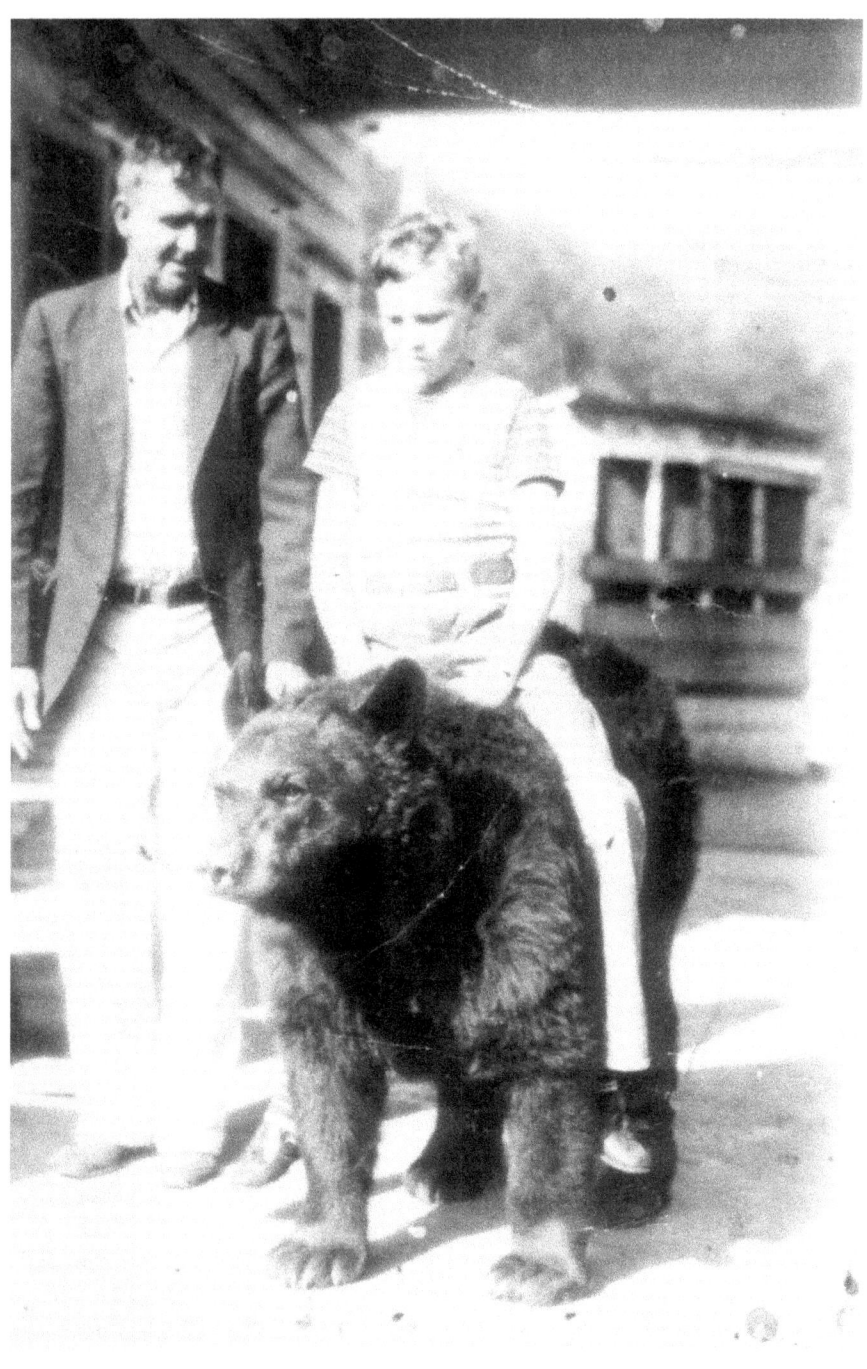

Charlie Turner's pet bear, "Smoky," was so tame that children rode on his back; the boy pictured is not identified. *Courtesy of Elizabeth Sparks.*

Animal Tales

Clarence Cochran Remembers the Half-Chicken/Half-Rooster

My dad, "Buck" Cochran, always had to have anything that was unusual. One day he told me to get in the car, that we were going after a remarkable chicken—one that was half-hen and half-rooster. After crossing Yahoola Creek on a swinging bridge, we came to the home of Miss Fannie McDonald, a retired schoolteacher who had a house full of beautiful antiques.

 Dad was a slick trader, and he talked for the longest time about everything except what he really wanted. It wasn't until he was halfway out the door that he remarked, "By the way, somebody told me you have a real peculiar chicken." Miss McDonald agreed to show him the chicken and eventually to sell it to him. You can guess who had to carry the bird home. It wasn't Dad!

 That chicken was one color on one side and another color on the other just like it was the halves of two different chickens joined together. It had a spur on one leg and nothing on the other. One week it would lay eggs and act like a hen; the next week it was getting romantic with the other hens! Sometimes it crowed and sometimes it clucked. Despite its peculiarities, it was a fine-looking fowl and strutted around like it was real proud of itself. Circuses all over the United States wanted to buy it, but Dad wouldn't part with his prize fowl.

 One day after we'd had the bird about a year and a half, a neighbor who was a professor at the college said, "Buck, I hate to tell you this, but your bird is dying." After the bird died, Professor Nicholson asked Dad to have it stuffed and sent to the College of Agriculture at the University of Georgia, and so far as I know, it's still there. When people asked Dad what caused the bird to die, he said, "I reckon it just plain died of confusion!"

Arch Bishop Remembers His Grandmother's "Pigeon Tales"

My grandmother, Louisa Payne, used to tell me stories her mother told her about going to see the Indians when she was a little girl in the 1820s and watching them do what was called a "Green Corn Dance." One time

they invited her to eat some sort of stew from their cooking pot, but she declined when she discovered that the meat was grub worms!

I also remember hearing my grandmother tell her pigeon tales. Back before passenger pigeons became extinct about 1914, they were so plentiful that it would take an hour for a flock to fly over, and they would nearly darken the sun. You could shoot a double-barreled shotgun up in the air without aiming, and pigeons would fall down like hail! There would be as many as fifty to a hundred nests in a big white oak tree.

After I got grown, I thought my grandmother must have been exaggerating because that was just too many pigeons. Later I found a book that said there might be as high as two billion birds in a two-hundred-mile-long flock. They made so much noise you could hear them for three miles, and when they roosted, they broke limbs off trees. It doesn't seem like that many birds could become extinct, but they were over-hunted both for food and for their feathers. Their long tail feather plumes were used to decorate women's hats.

Grandma Louisa frequently took me with her to dig herbs, and she knew plants that would cure any and everything that might be wrong with you. Whenever I got a runny nose or even a whimper, she put the tea to me! I still remember how bitter boneset tea was. The bitterer it was, the better she thought it worked.

Pop grew up over the mountain in Union County, and he used to bring his produce down the mountain on Grassy Gap Road, which was so steep he had to tie a tree to the back of the wagon for a brake. He always said that people who lived at the foot of the mountain never lacked for firewood!

Virstee Howell Remembers Seeing Bears on the Square

One of my earliest memories is of watching a pair of trained bears being led by halters and doing tricks in front of the courthouse. They were owned by two foreign gentlemen who were traveling through town. That must have been about 1920. After they finished their show, they walked on to the next town.

My grandmother, Castleberry Howell, was a slave owned by Elijah Castleberry, who owned a plantation on the Chestatee River south of Dahlonega. My daddy, Walter Howell, was born here in 1875 and worked for the Consolidated Gold Mines. He operated the electric motors that pulled ore cars out of the tunnels and dumped the ore into chutes to be melted down.

Animal Tales

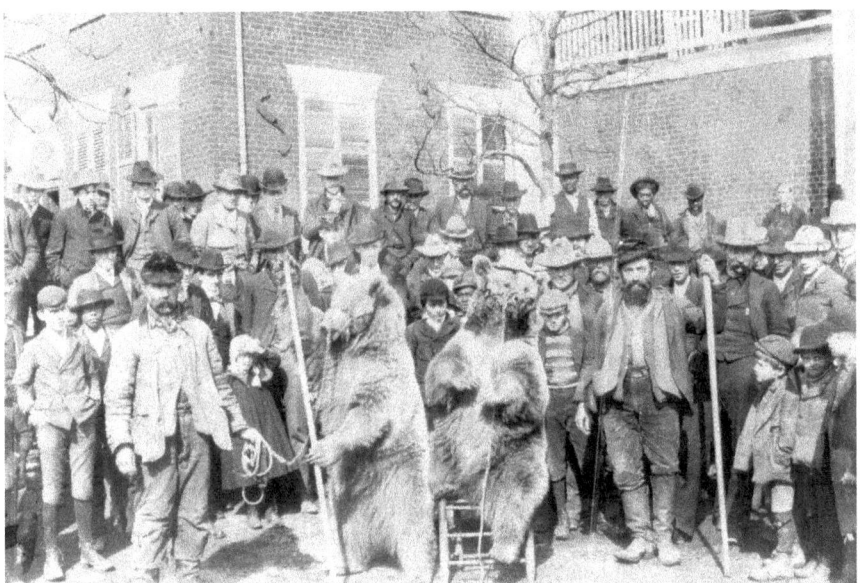

Many people gathered on the Dahlonega Public Square to watch this bear show in 1920; Virstee Howell is the young boy second from the left. *Courtesy of the Georgia Department of Archives and History.*

Daddy was also a "powder man" and later worked at the copper mine and the rock quarry. I can remember getting behind a tree many a time when Daddy would add a fuse and cap to some dynamite, put a mudpack on it and blast cracks in solid rock. The quarry supplied the rock for the twenty-ton crusher that was brought in when Highway 52 was the first road in the state to be asphalted. The crusher was propelled by a sixteen-mule team and was an impressive sight.

I can remember when there was a wooden bridge over Yahoola Creek just outside of town (on Highway 52 East). Daddy operated a freight line and crossed over that bridge on his trips to the wholesale places in Gainesville. He would leave Dahlonega at daybreak with his big covered wagon and four-mule team, stop in Murrayville at noon to feed and water his animals, and arrive at the wagon yard on Athens Street in Gainesville at sundown. The next morning he'd load up bright and early and head back to deliver his wares to the stores in Dahlonega. Before Highway 52 was paved, he sometimes got stuck and had to walk into town to get Mr. Hughes Moore's "snatch team" (three big mules abreast) to pull the wagon out of the mud.

The Best of "I Remember Dahlonega"

The old covered wooden bridge was located underneath where the present bridge crosses the Yahoola. A steel bridge was built in 1921, and you can still see where the old road curves off at the bottom of the hill. Daddy helped build that bridge, and I carried his dinner to him there many a time. They didn't use nuts and bolts then; instead, the metal was riveted together. A bellows was pedaled to fan the coals red hot. I can remember watching the red-hot rivets being lifted into place and then capped.

Folks used to come from all over for the annual fox hunting conventions that used to be held here. Men would spend a couple of weeks camping out in the woods with their foxhounds (Walkers and July hounds) until finally there were no more foxes left to hunt. About that time one of the Burns brothers who had moved to Texas shipped in some jackrabbits in the hopes of providing a new source of game.

I didn't know anything about jackrabbits when I was a lad of twelve out hunting some game for supper with Daddy's old shotgun. Suddenly this big ol' thing jumped out from behind some brush. At first I thought it was a young deer until I saw it didn't have split hooves. I thought to myself, "I don't know what it is, but I'm going to shoot it!" When I held it up, it stretched from my shoulder to my knees.

On the way home I passed by Mr. Charlie Stargel's. "What you got there, boy?" he asked. "Tell the truth, I don't know," I replied. Mr. Stargel told me it was a Texas jackrabbit, and he took a picture of me holding it.

My mother [Susie Elrod Howell] used to be the cook at the Mountain Lodge, and she taught all eleven of us children how to cook. I went to work in food services at the college when I was fifteen. When I was cooking at the Smith House in 1945, *Life* magazine featured a story on Court Week in Dahlonega, and one of the pictures shows me in a tall chef's hat serving a meal to Judge Candler. Later I went back into food services at the college and worked there for thirty-six years until I retired in 1976.

13.
Colorful Personalities

Almost all the people quoted in this book could be described as "colorful personalities." This chapter will feature two men who were not only colorful characters but whose lives had significant influence both locally and beyond.

If the discovery of gold put Dahlonega on the map, editor W.B. Townsend kept it there with his columns in the town's weekly newspaper, the *Dahlonega Nugget*, which he edited and published from 1897 until his death in 1934. His forthright and often humorous commentaries on life in Lumpkin County, as well as his pithy observations about life in general, were picked up and quoted in newspapers and magazines all over the United States.

Arthur Woody was Georgia's first forest ranger and served from 1918 until 1945. Under his skilled husbandry, the hunted-out forests were brought back to life as he imported deer and trout to stock north Georgia's woods and streams. His concern was not only for wildlife; he cared deeply about the mountain people as well and helped them in many ways that most folks did not realize.

In her article about Ranger Woody published in the February 16, 1969 issue of the *Atlanta Journal and Constitution Magazine*, columnist Lucy Justus called him "the father of wildlife management in the South" and noted that his conservation theories are still being taught in colleges and universities.

Editor W.B. Townsend Didn't Worry About Typos

William Benjamin Franklin Townsend learned the printer's trade working for Dahlonega's first newspaper, the *Mountain Signal*. In 1897 he leased the printing equipment of the fledgling rival newspaper, the *Dahlonega Nugget*, with only five

William Benjamin Franklin Townsend, editor of the *Dahlonega Nugget*. *Courtesy of the Dahlonega Gold Museum.*

Colorful Personalities

dollars in capital. Under his editorship, the newspaper was so successful that, by the time his lease had expired the following year, he not only purchased the paper on three years' credit but paid off the debt within two years.

In Townsend's day, newspaper type had to be laboriously set by hand, one letter at a time. Unlike other editors, Townsend never wrote out anything ahead of time but composed and set type simultaneously. Content was more important to him than form, and he never proofread what he wrote or worried about grammar, spelling, or typographical errors.

"If you see a typographical error in the *Nugget*, don't stop to criticize the editor," Townsend once wrote. "It won't hurt you or do you any harm." On another occasion he wrote, "Everybody who can read at all can understand what they see in the *Nugget*. We use no highfalutinary words. Don't know them. If we did we wouldn't use them."

What did concern Townsend was telling the truth of a situation as he saw it in plain, straightforward language. He deleted no names and softened no crimes. As a result, it was not uncommon for him to be threatened with libel suits.

"William Benjamin Franklin Townsend did not have much formal education, but he knew how to think" was how the late *Atlanta Constitution* columnist Jimmy Townsend described his outspoken uncle. "He knew right from wrong, and he was deeply set in his moral values and was determined to uphold them."

Townsend could "point more morals in a paragraph than a blooded setter could birds" was the way A.F. Dean described him in his book of the editor's writings, *Observations from a Peak in Lumpkin*, published initially as a column in the *Atlanta Journal*.

The editor had his idiosyncrasies: He was strongly opposed to concrete sidewalks because he thought they cost too much money. His stance against them was so strong that, whenever he came to a sidewalk, he would jump across rather than step on it! He also wrote numerous arguments against the city's new public water works because he thought the water was taken from a spring too near the cemetery. Even when tests showed the water was absolutely pure, he continued to refer to it as "graveyard juice" and would walk as far as necessary to get a drink from a well rather than a city tap!

The editor encouraged people submitting material to be used in the newspaper to "boil down your articles, just like you were cooking your pot of pumpkins. The longer it cooks the less it gets, but is much sweeter."

Townsend's sage sayings and penetrating thought earned him a reputation as "the second Benjamin Franklin," and his columns were reprinted in metropolitan newspapers and magazines throughout the United States and Canada. Under his editorship the *Dahlonega Nugget* was sent to approximately

two thousand subscribers, more than half of whom lived out of town. Many visitors to Dahlonega came simply because they wanted to meet the man.

Editor Townsend was as active as ever when he was in his early seventies, but a few days after his seventy-sixth birthday in 1934, he set type for what proved to be his last column, writing, "Ye editor is sick." He died a short time later.

W.B. Townsend left the *Nugget* to his son Jody, who persuaded his uncle, J. Goley Townsend, to return to Dahlonega and help him publish the newspaper. With Jody as editor and Goley as publisher, the weekly publication continued to be one of the best-known and best-read community newspapers in the United States. Although the Townsend name has not been associated with the paper for many years, the *Dahlonega Nugget* continues to publish "The Gold of the News" about Dahlonega and Lumpkin County.

Arthur Woody Was Georgia's First Forest Ranger

When the first Woody settled in the north Georgia mountains back in the 1830s, virgin timber covered the hillsides and game was plentiful. As more and more settlers moved into the area and hunted the woods to put meat on their tables, the once-plentiful game, including deer, bear, turkey and pheasant, became increasingly scarce. William Arthur Woody was a boy of twelve in 1896 when he watched his pa kill the last deer in the area. Young Arthur resolved then that he would make it his life's work to restore what the mountain men had ignorantly destroyed.

By the time Arthur was eighteen, he was married and the father of a son named Walter W. Woody. His wife, Emma "June" Abercrombie Woody, presented him with another son named Clyne Edward three years later and a daughter, Mae, in 1907.

Despite his father's dire warnings that he would starve to death working for the government, Arthur began working as a fireguard for the U.S. Forest Service in the fall of 1912. The knowledge that he gained on this job would later be put to good use preserving the woods of north Georgia. Once when he was asked what to do in case of a crown (treetop) fire, he responded without hesitation, "Run like hell and pray for rain!"

After working for a time surveying lands acquired by the Forest Service, Arthur became a forest guard responsible for protecting the national forest from trespassers and fires. The Forest Service was so impressed with Woody's skills that on July 1, 1918, he was sworn in as the first forest ranger in Georgia and put in charge of the entire Blue Ridge District, later named

Colorful Personalities

As Georgia's first forest ranger, Arthur Woody was responsible for the entire Blue Ridge District, later named the Chattahoochee National Forest. *Courtesy of Jean White McNey.*

the Chattahoochee National Forest. He was fond of boasting, "I make a thousand dollars a day, most of it in scenery."

Ranger Woody set many records for fire prevention. Once when he was asked the secret of his success, he replied nonchalantly, "Well, I'll tell you: I take a drink with all the men, kiss all the babies on the head, and tell all the women they are looking younger every day." His answer would appear irrelevant until one realizes that most forest fires at that time were deliberately set. Arthur Woody's attitude of good will toward all people went a long way toward preventing arson.

One of Woody's favorite sayings was, "a man's wealth is in his friends, not his money," and he had a deep concern for the people in the little community called Suches, located high in the mountains above Dahlonega. When a young man walked past the Woody house on his way to attend Martha Berry School in Rome, the Ranger asked him, "Do you have any money, Pedro?" ("Pedro" was Woody's pet name for everybody.) "Yessir, I have fifty cents," the young man replied. When he walked away, he had ten dollars in his pocket and later received additional contributions to continue his education.

Woody Gap School was built in 1940 on land donated by Arthur Woody with granite from his quarry and lumber sawed at his mill. This

kindergarten through twelfth grade school is one of the few remaining isolated schools still allowed to operate in Georgia today. Woody also contributed generously toward the building of Mount Lebanon Baptist Church in Suches, claiming to do so because he wanted to be sure to have "a place large enough for my funeral."

Woody, popularly known as "The Kingfish," was an entrepreneur as well as a forest ranger and eventually became one of the wealthiest men in the area through his dealings with cattle, land and loans. He was so generous with his money that one wonders how there was any left for himself. A man known for not paying his debts once came to see him about borrowing some money. After he had left, June Woody asked her husband why he had given him a loan, knowing he would likely never get it back. "Well, I just couldn't let his young-uns go hungry this winter," the softhearted ranger replied.

Returning from the funeral of a mountain farmer one day, Woody went through his files looking for a certain document, which he proceeded to tear up and burn. When his wife asked what he was doing, she was told, "When the widow woman comes inquiring about the mortgage, tell her it was cleared up before her husband died."

On the other hand, numerous parcels of land were added to the national forest by the Ranger's foreclosure on the property of those who were unwise enough to hunt out of season!

Arthur Woody was at home with people from all walks of life, and he was comfortable with being himself. When Governor Ed Rivers was staying at the Woody home the night before he was to speak at an Easter sunrise service to be held at Woody Gap, Arthur didn't let the distinguished visitor interfere with his regular bedtime. Promptly at 8:30 p.m., he took off his shoes, yawned and announced, "Well, I'm going to bed now, Little Eddy, but you make yourself at home and stay up as long as you like."

In 1928, Ranger Woody began taking steps to fulfill his boyhood resolve to restore the deer population in north Georgia. With money out of his own pocket, he bought three western mule deer left behind by a traveling circus. He also purchased five fawns from the Pisgah National Forest in North Carolina and raised them in a pen near his house. He mixed their formula and bottle-fed them every six hours day and night until they were old enough to eat on their own. They became great pets and were named Nimble, Bessie, Billy, Nancy and Bunnie-Girl.

Arthur Woody's grandson, Ned White, recalls another pet deer named Peggy, who would frequently wander into the house and seemed fascinated by her reflection in the mirror. When she was later killed by a hunter in what

Colorful Personalities

was supposed to have been a buck hunt, Ned remembers that his grandpa was "fit to be tied."

When wildlife specialists from the Georgia Game and Fish Commission came into the area to determine if the deer population had become large enough to allow hunting, Woody is reported to have led them to an area which had few signs of deer so they would postpone hunting for another year, thus giving the deer another year to multiply. By 1941, the deer population had gone from zero to at least two thousand, thanks to Ranger Woody's efforts.

Many people think that the brown trout is indigenous to the streams of north Georgia, but it is, in fact, imported just like the rainbow trout. The only fish found previously in the streams were minnows and horny heads. Ranger Woody met the train in Gainesville when the first rainbow trout arrived from Denver, Colorado, in 1918. He hauled them by truck to the foot of Black Mountain, where he transferred them to a wagon for the steep and winding journey up Grassy Gap Road to Suches to be put into the streams.

Woody also imported bears to replenish the bear population, and he raised two cubs named Mike and Ike. His granddaughter, Jean White McNey, recalls that the lively cubs once escaped from their pen and were having a merry time swimming in the lake in front of the Woody home. The pants legs of the assistant ranger sent to retrieve them were hanging in shreds before he finally got them into his canoe and back into their pen!

Under Ranger Woody's skilled husbandry, the forest of the Blue Ridge came back to life. His methods were frequently unorthodox, and he drove Forestry Service officials crazy because he refused to follow the rules and go "by the book." However, no one could argue with his successful results.

Dockery Lake was built by a crew of Woody's men according to his specifications. Irate government officials whose technical expertise had not been consulted insisted that the dam would never hold, and they erected two additional dams farther downstream, following federal guidelines. When floods later washed away both their dams, Woody's dam remained intact!

One of Arthur's dreams was to have a road built from Stone Pile Gap to Suches through Woody Gap [named for his great-grandfather, John Wesley Woody]. When he heard that funds were available and applied for them, he was told that the money was only for road improvement, not the creation of new roads. Undaunted, Woody got a crew of men and cleared land for a roadbed. He then went back and announced, "I've done built a road. Now improve it!"

Ned White recalls that when the University of Georgia offered his grandfather an honorary degree in forestry, Arthur wanted to know what he had to do to get it. When told all he had to do was get dressed up and

Ranger Arthur Woody worked diligently to restore and preserve the wildlife in north Georgia. *Courtesy of Jean White McNey.*

Colorful Personalities

go to Athens, his next question was, "Am I going to know any more than I know now?" When told no, he announced, "Well then, I won't go."

Ranger Woody suffered a slight stroke in September of 1944 and retired from the Forest Service a year later when he realized he could no longer do his job the way he thought it ought to be done. His health continued to deteriorate, but he never lost his cheerful sense of humor. "I've had a good life, and I've accomplished what I wanted to do," he maintained. "All I ask is that you bury me so I can see Black Mountain when I come up out of the grave on Resurrection day."

When Ranger Arthur Woody died on June 10, 1946, more than fifteen hundred people came to pay their respects. He was laid to rest in the cemetery at Mount Lebanon Church, nestled in the shadow of the mountain he loved and husbanded so well. None who knew him will ever forget him, and countless others who never met him in person enjoy the legacy of scenery and wildlife he worked so diligently to restore and preserve.

14.
Exciting Events

The founders of the early churches, who sought to transform the rough and rowdy gold mining settlement called Dahlonega into a safe and respectable family community, gradually succeeded. To a casual observer, Dahlonega would appear to have settled down into a sleepy little town by the early 1900s. The excitement of its earlier days, however, was not entirely absent even after the turn of the century, and a number of unusual events gave local folk plenty to talk about at the time and to reminisce about even today.

TRAIN ROBBERS WERE CAPTURED NEAR DAHLONEGA IN 1911

On February 11, 1911, Lumpkin County Sheriff John F. Sargent received an urgent telephone call from the Hall County sheriff, advising him of a daring train robbery that had taken place six miles from Gainesville early the previous day. The holdup sounded like a tale out of the old Wild West.

Most of the passengers were sleeping when the engineer stopped the train around 3 a.m. in response to a red light ahead signifying danger. Stepping off the train, the conductor saw a shadowy figure and called out to ask what the trouble was. He soon found himself looking into the barrel of a gun and was ordered back on the train.

After failing to get into the train's large safe by exploding dynamite under it, the armed bandits turned their attention to a smaller safe and quickly emptied its contents. Before most of the sleepy passengers realized what was happening, the robbers were gone.

Exciting Events

Train robber Bill Miner after his capture on February 22, 1911; photo taken by photographer W.J. Ramsey. *Left to right*: Sheriff John F. Sargent, Bill Miner and Southern Railway Detective Tom N. Hanie. From the *Atlanta Constitution*, February 24, 1911. *Courtesy of Bill Keith.*

Bloodhounds were brought in but were unable to pick up a trail. Desperate for a lead, law officials began calling sheriffs in surrounding counties asking them to be on the lookout for three men, the leader of whom was described as being taller and some years older than his two accomplices.

Hearing their description, Sheriff Sargent immediately remembered three men who had stayed at his newly opened hotel on the square the previous Sunday. They had claimed to be prospectors on their way up into the mountains to search for gold, but they had no mining tools, and when they left Dahlonega the next morning, they took the route toward Gainesville—away from the mountains.

Enquiries revealed that a stranger had bought some tobacco and candy at McGuire's soda fount and six boxes of snuff at J.W. Moore's store. It was determined that the snuff was to put in the outlaws' shoes to keep dogs from being able to track them.

Despite the snuff, a posse which included Sheriff Sargent, former Sheriff Jim Davis, and his sons Rufus and Joe, followed a trail that led seventeen miles west of Dahlonega to the Elbert Kendall farm near Nimblewill. Mr.

Kendall was aroused from his bed by loud knocking and appeared at the door clad in his nightshirt. In those days it was customary to extend hospitality to passing travelers. In response to their enquiry, Mr. Kendall told the lawmen that he and his wife had invited a courteous elderly gentleman to eat supper with them and sleep in the loft with the four Kendall sons.

The man in question did not resist arrest despite the pistol under his pillow, for posse members were blocking his only avenue of escape. On the way back to town he was caught trying to dispose of a purse containing $422.50 in English gold coins taken from the train.

The sixty-eight-year-old villain was later identified as none other than the infamous train robber known by many alias names, including Bill Miner, nicknamed "The Gray Fox." During the two days he was held in jail in Dahlonega before being transferred to Gainesville, Miner is reported to have conversed very intelligently about numerous subjects, including gold mining in Lumpkin County. His two accomplices were also captured and soon confessed to their part in the train robbery.

A Foiled Bank Robbery

About 2 a.m. one morning in February of 1913, a young man living in a second-story apartment on the Dahlonega Public Square was awakened by a noise outside. Walking out on the porch to investigate, he saw robbers breaking into the bank next door. They spotted him also and threatened to kill him if he opened his mouth. He quietly stepped back inside and dialed the telephone exchange.

"Mr. Bob" Meaders not only ran the telephone exchange; he was also president of the bank. Telling his wife Maggie to call the sheriff, Meaders grabbed his pistol and slipped out the back door to make his way behind buildings toward the bank. When the lookout posted near the courthouse saw "Miss Maggie" appear in the window, he fired several shots at her. Ignoring the broken glass, she crouched down out of sight but kept one finger holding back the toggle switch and rang the sheriff with the other hand. In the meantime, "Mr. Bob" was shooting at the lookout.

When the sheriff arrived, he gave Meaders another pistol, and the two of them went down the sidewalk firing four guns like a scene out of a Western movie! The robbers broke and ran around the corner to escape the bullets. They got away but were found two days later sleeping in a ditch northwest of town.

It came out later at their trial that the five culprits had successfully robbed major banks in the past, and they apparently thought a small-town bank would be "easy pickin's." They were obviously unfamiliar with the type of safe with two

Exciting Events

The small building to the left of Hall House was the bank of Lumpkin County when robbers attempted to dynamite open the safe in 1913. *Courtesy of the author.*

front doors. After drilling through the outer door, they attempted to blast through the inner door, but the explosion sealed it into the safe to produce what amounted to a solid steel box. The safe had to be taken outside and torched open.

EARLY SILENT MOVIES WERE FILMED IN DAHLONEGA

Six or seven silent movies were filmed on location in and around the town not long after the advent of the moving picture. Dahlonega's abandoned gold mines, mining cuts and mountainous scenery provided a setting that looked western but was considerably more accessible back in the days when film companies were based in New York.

On March 15, 1915, Fox Film Company's famed motion picture director, Edgar Lewis, set out from the company's headquarters in New York to begin filming *The Plunderer*, a movie based on the best-selling novel by Roy North, a celebrated author of Western stories. Accompanying Lewis was leading man William Farnum, the screen star who was the Hopalong Cassidy of his day, and about twenty other actors and actresses, including leading lady Miss Claire Whitney.

The Best of "I Remember Dahlonega"

Film star William Farnum (left) in Dahlonega while filming *The Plunderer. Courtesy of the author.*

It was just over a day's journey by train to Gainesville, where all the filming equipment and baggage was transferred to rented wagons to be conveyed the remaining twenty-five miles through the mountains to Dahlonega. The unpaved road was either dusty or muddy, depending on the weather. When the weary travelers finally arrived in Dahlonega, no doubt thinking they had come to the end of the earth, they rested and recuperated at the Mountain Inn, a large hotel overlooking the town.

The proprietor, Dr. Craig Arnold, treated his Northern guests to a lavish table of Southern cooking, not all of which was appreciated. When the actors heard local folks talking about how good possum meat was, they expressed a desire to try it. "Doc" Arnold obligingly had his kitchen staff prepare several fat opossums served with sweet potatoes. It was reported that picture taking had to be abandoned the next day because all the actors were sick!

In addition to housing and feeding the actors, Dr. Arnold assisted the director in locating suitable backgrounds and local people to use as extras. In addition to the thrill of being in a movie, extras were paid $1.00 per morning and $1.50 if they worked into the afternoon. Arnold was recruited to play the part of a rich mine and timber owner. Other local citizens closed up shop and turned out to watch the filming.

Exciting Events

Margaret Meaders remembered watching the scene in which platinum blond Claire Whitney rode "hell-for-leather" on a white horse down a mountainside mining flume, one jump ahead of the villain pursuing her. Meaders reported that Miss Whitney made about twenty-five such headlong flights before the director was finally satisfied. On one occasion Whitney's horse ran away with her and threw her to ground, but fortunately her injuries were only minor. One of the pack animals didn't fare as well. He shied at a camera and plunged off Findley Ridge to an unscheduled death at the bottom of the chasm.

Hardy Price drove a team of oxen in the movie, and Charlie Free owned the mule that fell off the cliff. Robert Moore was paid five dollars a day for the use of his horse, which included saddling and currying it. Robert's brother Henry drove the movie cast out to Black Mountain Road to film a log cabin scene. Henry was a camera buff who took the only known locally made snapshots of the actors and actresses.

Jess McDonald played the role of the blacksmith in the movie. He liked to tell about the time the director told all the extras to go home and put on their oldest clothes and look as bad as they could. When one old mountaineer asked if he should go change also, Mr. Lewis shook his head, saying, "No, I don't see how you could look any worse than you already do."

Editor Townsend of the *Dahlonega Nugget* described *The Plunderer* as "a true, wild mining play and requires the use of large mills, pipe lines, underground workings and power plants, all of which were found here, just as desired and these within the corporate limits of the City. This picture will spread the fame of Dahlonega over the entire world and show the natural beauty of our mountains, the many large open cuts where gold was taken in years past and create a renewed interest in gold mining."

There was no theater in Dahlonega when *The Plunderer* was released, but a review of the film indicates that it was shown at the Strand Theater in Atlanta. None of the people who watched the filming could remember ever seeing it on screen.

Several other silent films were made in Dahlonega in subsequent years. *The Life Without a Soul* was Ocean Film Company's production of Mary Shelley's book *Frankenstein*, but there is no indication why Dahlonega was chosen as its locale. In one of the scenes, the actor playing the role of the monster was supposed to go into a terrible rage, knock out windows, tear up furniture and play havoc in general. He played the part so well that the company had to pay to repair and refurnish the hotel!

Another Western entitled *Big Jim Garrity* was filmed in Dahlonega by Pathe Freres. Dr. Craig Arnold had a role in it as the mine doctor called to

The Best of "I Remember Dahlonega"

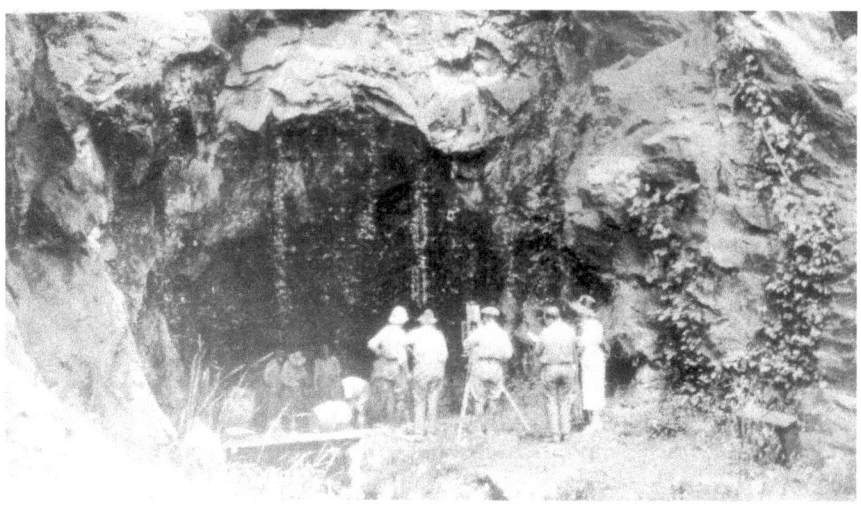

Fox Film Company on location in Dahlonega filming *The Plunderer* in 1915. *Courtesy of Henry W. Moore.*

resuscitate twenty-five men caught in a flooded mine. Arnold also played the innkeeper in *The Life Without a Soul.*

The company filming *The Great Divide* moved from Arizona to Dahlonega to shoot several scenes about a gold-bearing ridge honeycombed with mining shafts and old hydraulic workings. The story was about a villain who was killed in a landslide in the Grand Canyon, but since artificial landslides were not permitted in that area, it was filmed on Crown Mountain just south of Dahlonega instead. The cameraman had to do some trick photography, since Crown Mountain was not nearly as high a precipice as called for by the script.

A film entitled *Driven,* produced in the early 1920s by Brabin Productions, Inc., of New York, was about an old mountaineer, his three moonshiner sons, and a fourth son who turned out to be the hero. The picture was filmed with some of north Georgia's most beautiful and rugged scenery in the background, including Amicalola Falls, Brasstown Bald, Blood Mountain and Mount Yonah.

The Daughter of Devil Dan, produced by Buffalo Pictures Company, created some excitement not in the script. One of the scenes took place in a little cove on Yahoola Creek, where a moonshine still was part of the set. Irma Harrison, the leading lady, was beseeching her father, Devil Dan, to give up his illegal trade. She would then blow up the dam upstream to remove all traces of the still before her sweetheart arrived to arrest the moonshiners. About that time a real bullet was fired, and a real U.S. Marshall crashed the scene. No amount of explaining could convince the

Exciting Events

officer that they were actors and not moonshiners! He arrested the whole cast, and the company had to make bond for their appearance in the federal court at Gainesville!

All attempts to locate copies of these old silent films have been fruitless. They were probably among the early films destroyed in a warehouse fire some years ago. It is true that the quality of the photography would be disappointing to those of us accustomed to modern filming techniques, but if one of these historic films should turn up, it would be like a time machine to transport us back into the past to view scenes that have otherwise disappeared forever.

A Wagon Train Carried Dahlonega Gold for the Capitol Dome

The morning of August 4, 1958, looked more like 1858 in Dahlonega. Bearded men were busy harnessing mules to covered wagons loaded with water barrels, coffee pots, sleeping quilts and other items needed for a journey. Women in old-fashioned, ankle-length dresses were seeing to the food and keeping a watchful eye on a number of excited, barefooted children.

At last everything was in readiness, and people began climbing into the wagons. Some men were drivers; others mounted horses. As the "Let 'em roll!" shout came from the wagon master, the line of seven wagons loaded with passengers from four to sixty years of age began to move slowly around the courthouse and out of town. A sign on the lead wagon told the story.

<div align="center">
DAHLONEGA

Lumpkin Co. Wagon Train

Bearing GOLD for

CAPITOL DOME
</div>

It was a former Dahlonegan named Gordon Price who first had the idea of using native Georgia gold to gild the dome of the state capitol building. As he sat in his law office looking out on the capitol and reading a newspaper article about plans to repair the dome, Price visualized how it would look sparkling in the sun if it could be covered with gold.

Price shared his idea with the capitol architect, A. Thomas Bradbury, and the two of them took the idea to Secretary of State Ben W. Fortson Jr., and Governor Marvin Griffin. When the governor was convinced that the gold would be donated and there would be little cost other than that originally appropriated for repairs, he was in favor of the project.

The Best of "I Remember Dahlonega"

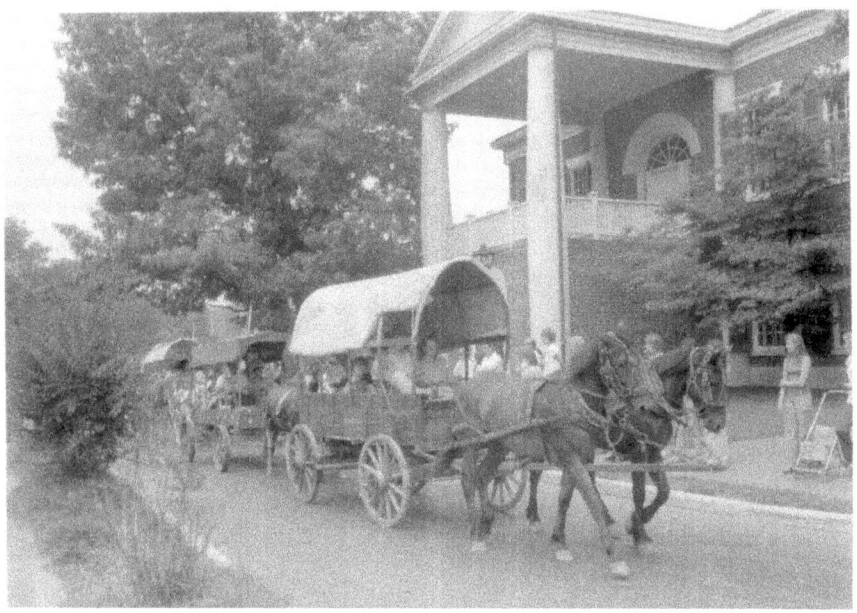

The wagon train passing in front of the Lumpkin County Courthouse on its journey to take Dahlonega gold to Atlanta to gild the dome of the capitol. *Courtesy of the Dahlonega Gold Museum.*

The Dahlonega Chamber of Commerce accepted the invitation to head up the project. Soon people were busy prospecting every nook and cranny of the county in search of gold overlooked by miners in the past. Descendants of Lumpkin County miners donated gold that had been in the family for generations to the cause, and those who had no gold gave money for its purchase.

Three months later the necessary forty-three ounces of gold had been collected. It could have been delivered to Atlanta in an armored car, but it wasn't. Local historian Madeleine Anthony thought it would be far more noteworthy to carry the gold to the capitol by an old-time wagon train.

At first people said it couldn't be done. They said the mules would drop, the wagons would fall apart, women would pass out from heat and exhaustion, and they would all be killed by trucks on the highway. Gradually, the idea began to catch on, and folks began rounding up mules and wagons and old-fashioned attire to wear.

Early on the morning of August 4, most of the townspeople gathered to see the wagon train off, and all along the way people gathered to see it pass, offering the travelers soft drinks and watermelon to quench their thirst in the summer heat.

Exciting Events

Two state patrol cars had been assigned to the convoy but were unable to keep their batteries charged at the plodding rate of three miles per hour. It fell to wagon master Hughes Moore and scout Billy Moore to ride their horses at the front and rear of the wagon train carrying red flags. Since the roads were only two-lane, they had to stop traffic from both directions and route it single-file around the wagons. Most drivers were so busy gawking at the astonishing sight of mules, wagons and shotgun-carrying men on horseback that they didn't seem to mind the delay.

When the travelers reached Cumming, they were greeted not only by the citizens of that town but also by fellow Dahlonegans, who drove down in cars and trucks bringing food for supper. Riders unaccustomed to spending a whole day in the saddle and raw from ankles to elbows bought all the jars of Vaseline to be found in Cumming stores and used it liberally!

By the time they finished supper, rubbed down the mules and horses and greased the wagons, the travelers were too tired to be kept awake by the discomforts of sleeping outdoors in or under their wagons. It was still dark when they began lighting charcoal fires for breakfast the next morning.

The people of Alpharetta provided lunch for the wagon train on the second day of their journey, and the mayor of Roswell gave them the key to the city when they arrived there that evening. The people of Roswell not only provided supper but also opened the town's swimming pool to them.

Excitement was high on Thursday morning as the wagon train headed down Peachtree Street toward the capitol with police cars as escorts and the Third Army Band greeting them with rousing strains of "Dixie." Scout Billy Moore rode his horse Flash up the capitol steps, firing his muzzle-loader (loaded with paper) and yelling, "Where's the governor? The gold is here!"

Behind him, Madeleine Anthony and Louella Moore carried the precious cargo in an old chest that once belonged to William Few—one of Georgia's 1787 signers of the United States Constitution—on loan from the State Department of Archives for the historic occasion.

Governor Griffin appeared, and Dahlonega Chamber of Commerce president Bill Fry, formally presented the gold. Speaking on behalf of the people of Georgia, the governor accepted the gift of the people of Lumpkin County and expressed his appreciation to them, saying:

"The colorful journey to deliver this gold in a proper historical manner will certainly illustrate not only the native pride of Georgians in their historical heritage but should bring this event into national focus."

Their mission successfully completed, members of the wagon train piled gratefully into cars driven to Atlanta by friends and relatives to bring them

home in comfort. Animals and wagons were loaded into trucks provided by Dahlonega merchants Robert, Henry and Corky Moore.

The gold was sent to Philadelphia and converted into gold leaf $1/5000^{th}$ of an inch thick. The 300-foot rolls were then sent back to Atlanta and applied to the capitol dome by steeplejacks. After its gilding with Dahlonega gold, the dome became an even more prominent Atlanta landmark, sparkling and glittering for miles around.

Index

A

Abee, Eli 83
Abee, Roy 97
Abercrombie, Almira
 Baugus 88, 89
Abercrombie, Charlie 71
Abercrombie, Johnny 31
Abercrombie, Virginia 46
Adams, Ethel Price 96
Adams, Ross 25
Anthony, Madeleine 122,
 123
Antioch Baptist Church 34
Armour, Rada 29
Arnold, Doc 22, 23, 118,
 120
Ash, Leola 58
Auraria 27, 32, 33, 34, 35,
 36, 37, 90, 93
Austin, Ester 84
Avery, 91

B

Baker, Rufe Ed 57
Barnes, Olin 58
Beasley, Jack 84
Berry, Hannah Grizzle 55
Berry, Violet Smith 44
Berry, Willie 55
Bishop, Arch 102
Boartfield, Frederick D. 22
Boartfield, John 22
Boatfield, Marion 22
Boyd, Joe 71
Bradbury, A. Thomas 122
Brown, Nell Todd 46
Bryan, Fannie Lou 56
Bryan, Sheals 57
Burns, Fred 95
Burns, Gordon 57
Burns, Lula Fields 40
Butler, Fred 84
Butler, Will 84

C

Caldwell, Cardelia Walker
 46, 78, 96
Caldwell, Herman 78
Caldwell, Monroe 78
Calhoun, John C. 34
Cannon, Oscar 63, 99
Cantrell, 52
Carter, Farish 34
Castleberry, Elijah 103
Cherokee Nation 15, 28
Chestatee River 15, 17, 21,
 29, 99, 103
Chester, Chalmer 93
Chester, Icalona Waters 92
Chester, M. Calvin 92
Christian, Albert 90
Christian, Ed 93
Christian, Frank 75, 77
Christian, Lillie Chester 91
Christian, Sara 75
Civil War 17, 18, 29, 38,
 39, 40, 41, 46, 88
Clay, Henry 34
Cochran, Clarence 69, 91,
 101
Cochran, Henry Buchanan
 69, 70, 89
Collins, Claude 41
Collins, Johnny 52
Collins, Nettie 51
Consolidated Gold Mining
 Company 19, 21,
 22, 103
Crane, William James 40
Crisson, E.E. 21
Crisson, Elijah 19
Crisson, John 19
Crisson, Reese 21
Crisson, William Reese 19
Crisson Mine 19, 21
Cumming 123

D

Dahlonega Branch Mint
 17, 18, 19, 22
Dahlonega Chamber of
 Commerce 122, 124
Dahlonega Nugget 10, 52,
 105, 107, 108, 119
Davis, C.C. 25, 96
Davis, Daniel 27, 28

The Best of "I Remember Dahlonega"

Davis, Dola 29
Davis, Jim 115
Davis, Rachel Martin 27, 28
Davis, Walker Dan 27–29
Dean, A.F. 107
Dean, William 32
Dockery, Andrew John 64
Dockery, Wesley 64
Dowdy, Jack 40, 44
Dowdy, Jacob E. 40
Doyle, Vee Dyer 80
Dyer, Mary Jarrard 80
Dyer, William Joseph 80

E

Etowah River 25, 27, 51, 67, 77

F

Fields, Boling 21
Fields, Mathilda 21
Fields, Viola Berry 54
Fitts, J. Clynton 91
Fitts, Ralph 96
Fortson, Ben W. 122
Fox Film Company 117
Free, Charlie 119
Frogtown 28, 29, 31
Fry, Bill 124

G

Garrett, Elmer 39, 44
Garrett, Luther 39
Garrett, M.H. 81
Gibson, Marcella Crane 40, 46
Glaze, Vernon 58
Gold Museum 37
Gooch, Bill 45, 78
Gooch, Herbert 65
Gooch, Ruby 81
Graves, Rachel Patrick 41
Green, Helen Head 66
Griffin, Governor Marvin 122
Grizzle, Duffie 59

H

Harkins, Berbie Robinson 47
Head, Dr. Homer M. 66
Hightower, Maude 81
Hightower, Rupert 65
Hood, Fred 94
Housley, Boyd and Will 81
Howell, Castleberry 103
Howell, Susie Elrod 104
Howell, Virstee 83, 102, 103–104
Howell, Walter 103

J

Jenkins, George Washington 24
Jenkins, Robert 24
Jenkins, Tom 24
Jones, Ada 31
Jones, Fred, Sr. 65
Jones, J.B. 28, 46
Jones, William 28, 29
Justus, Lucy 105

K

Kanaday, Parley 66
Kelley, Sally Bryant 77
Kendall, Elbert 116
Kenimer, Doris 81

L

Lance, John R. 41
Lingerfelt, Elsie 61
Lipscomb, D.H. 80
Lipscomb, Edna 80
Lipscomb, George 81, 95
Lydia School 90

M

Martin, Dorsey 10
McClure, Nina 67
McDonald, Barbara 41
McDonald, Clara Satterfield 22
McDonald, Fannie 101
McDonald, Jess 119
McDonald, Jesse 22
McDougald, Joseph 41
McNey, Jean White 111
Meaders, Margaret 119
Meaders, Mr. Bob 116
Miner, Bill 116
Moore, Billy 123
Moore, Corky 124
Moore, Elizabeth 71
Moore, Henry 71, 124
Moore, Hughes 104, 123
Moore, Louella 123
Moore, Mr. John 73
Moore, Mrs. John 67
Moore, Ola Smith 79
Moore, Robert 80, 119, 124

N

NASCAR 75, 76, 77, 78
Neel's Gap 29, 73
Nimblewill 54, 56, 69, 91, 92, 116
North Georgia Agricultural College 67, 69, 88
Nuckolls, Nathaniel 32, 34

O

Odum, Larry 75
Owens, Glad 43, 46

P

Parks, Benjamin 17, 19
Parks, Frank 81
Parks, Woodrow 81
Paschal, Agnes 33, 34, 35
Paschal, George W. 33
Payne, Louisa 102
Poore, Eulene 45
Poore, Mary 45
Porter, Nancy Jane Cain 40
Price, Gordon 121
Price, Hardy 119
Pruitt, Curly 52
Pruitt, James Russell 54
Pruitt, Mary Girlie Gillespie 53

Index

R

Ray, Mae Smith 96
Rider, 51
Rider, Homer 78
Rider, Hubert 78
Ridley, Alex 40
Ridley, Callie 63
Ridley, Charlie 60
Ridley, Ed 40
Ridley, Henry and Frank 73
Riley, Fred 84
Rivers, Governor Ed 66, 91, 110
Roswell 123

S

Saine, Lois 50
Saine, Sam 50
Saine, Will 50
Sanderson, Llenell Jones 65
Sargent, Sheriff John F. 114
Satterfield, Dewey 98
Satterfield, Florethel 98
Satterfield, John 63
Satterfield, Laurin 41
School, Woody Gap 110
Scott, Winfield 27
Seabolt, Anapearl Walker 89
Seabolt, Loudean Jarrard 90
Sequoya 26
Sheriff, John 39
Smith, H.B. and Bessie 83
Smith, Vernon 10
Smith House 83, 84, 104
Souther, Monteen 88
Sparkes, Malone 41
Strickland, Mary 83
Stringer, Charlie 71
Suches 71, 72, 99, 109, 110, 111
Sullens, Myrtle Ledford 45
Sutton, Ora 29

T

Talmadge, Governor Herman 99
Townsend, J. Goley 108
Townsend, Jimmy 107
Townsend, Jody 25
Townsend, W.B. 105, 106, 108
Trail of Tears 27, 28
Trammell, Amy 33, 35, 37
Trammell, Bill 35
Trammell, Clydie 94
Turner, Charlie 99
Turner's Corner 99, 101

V

Vaughn, Rachel Sparkes 41

W

Wahoo Church 58
Walden, Fannie 56
Walden, Leamon 45
Walker, Captain 44, 65
Wehunt, Maggie Waters 48
Welch, Fred 83
Welch, Thelma 84
West, Dr. S.A. 52, 65
West, Harold 64
White, Ned 111, 113
Wimpy, Frank Homer 56
Woody, Arthur 11, 105, 108, 109, 110, 111, 113
Woody, Emma June 108
Woody, John Wesley 111
Woody, Walter W. 108
Woody Gap School 71, 72, 73, 78, 110, 111

Y

Yahoola Creek 22, 60, 67, 101, 103, 121
Yahoola Ditch 18
Yahoola Valley 67, 78

About the Author

Anne Dismukes Amerson is a native of Dahlonega and a 1956 graduate of North Georgia College. She spent twenty-three years as an army wife, during which time she earned a Master's degree at the University of Hawaii. She and her husband Amos retired and moved back to Dahlonega in 1979.

Anne has been researching and writing about local history since 1989. She wrote a weekly column for the *Dahlonega Nugget* for ten years and has published four volumes entitled *I Remember Dahlonega*. She has also authored Dahlonega's *Historic Public Square* and co-authored *Screen & Stage: The Story of Dahlonega's Historic Holly Theatre*. She continues to write articles for the quarterly magazine, *Georgia Backroads* (formerly the *North Georgia Journal*).

When she isn't writing about local history, Anne is often found talking about it to various organizations. She has been the featured speaker at the Metropolitan Coin Club of Atlanta, the Georgia Numismatic Association's 2000 Coin Show in Dalton and the American Numismatic Association's 2001 Coin Show in Atlanta. In 2003 she was selected as "Georgia Author of the Year" by the Georgia Association of College Stores and was guest speaker for their annual meeting.

An active member of the Lumpkin County Historical Society, Anne is co-editor of the Society's newsletter. She was the first recipient of the Historical Society's Madeleine K. Anthony Award for Historic Preservation. In 2003 she was named a "Humanities Hero" by Georgia Governor Sonny Perdue.

www.ingramcontent.com/pod-product-compliance
Lightning Source LLC
Chambersburg PA
CBHW071411160426
42813CB00085B/1040